Refracting Sunlight

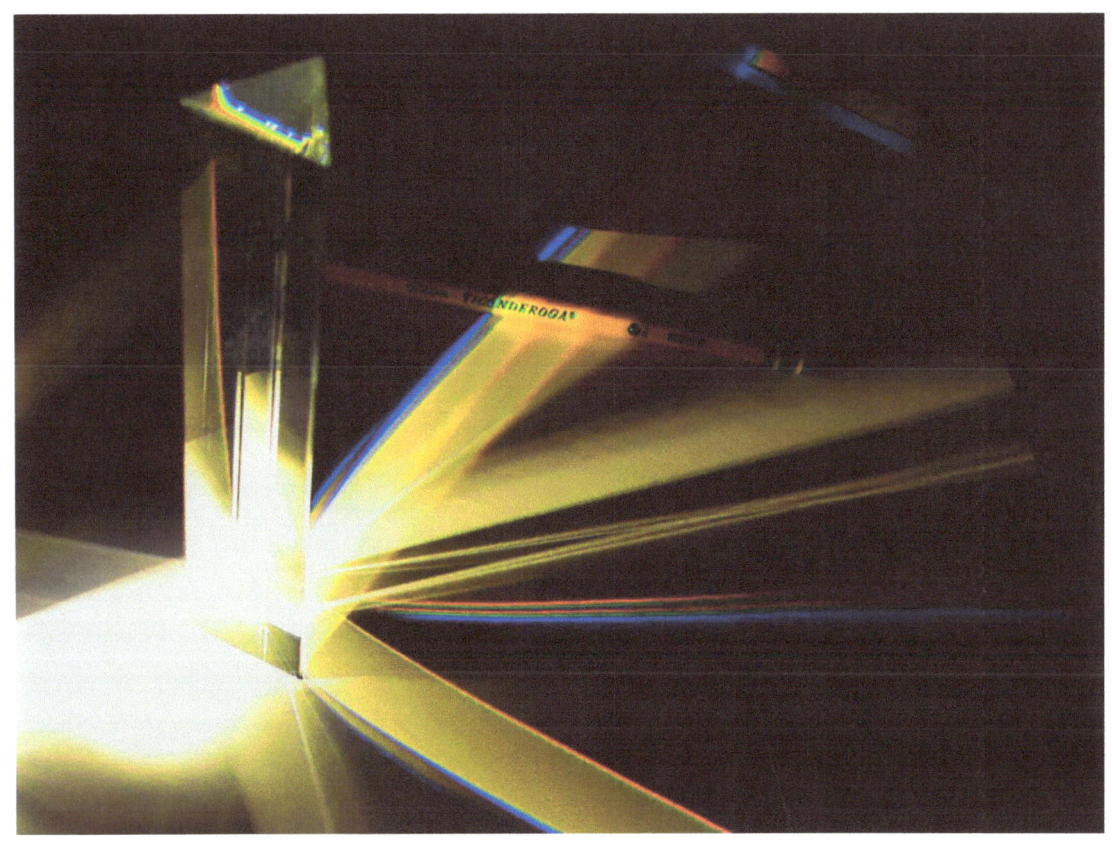

More Haiku and Senryū Illustrated

By

Düg Fresh

© 02019 Fresh Ink
Skahnéhtati, New York
Independently published.
www.freshspace.net

To the sunlight refracting in all of us
and to Augustus and Heidi for shining bright.

To me, photography is not just a visual art, but something closer to poetry - or at least to some poetry, such as the haiku.
 - Frank Horvat, Photographer

Haiku is an art that seems dedicated to making people pay attention to the preciousness and particularity of every moment of existence. I think that poetry can do that.
 - Robert Hass, Poet

Meaning lies as much in the mind of the reader as in the Haiku.
 - Douglas Hofstadter, Cognitive Scientist

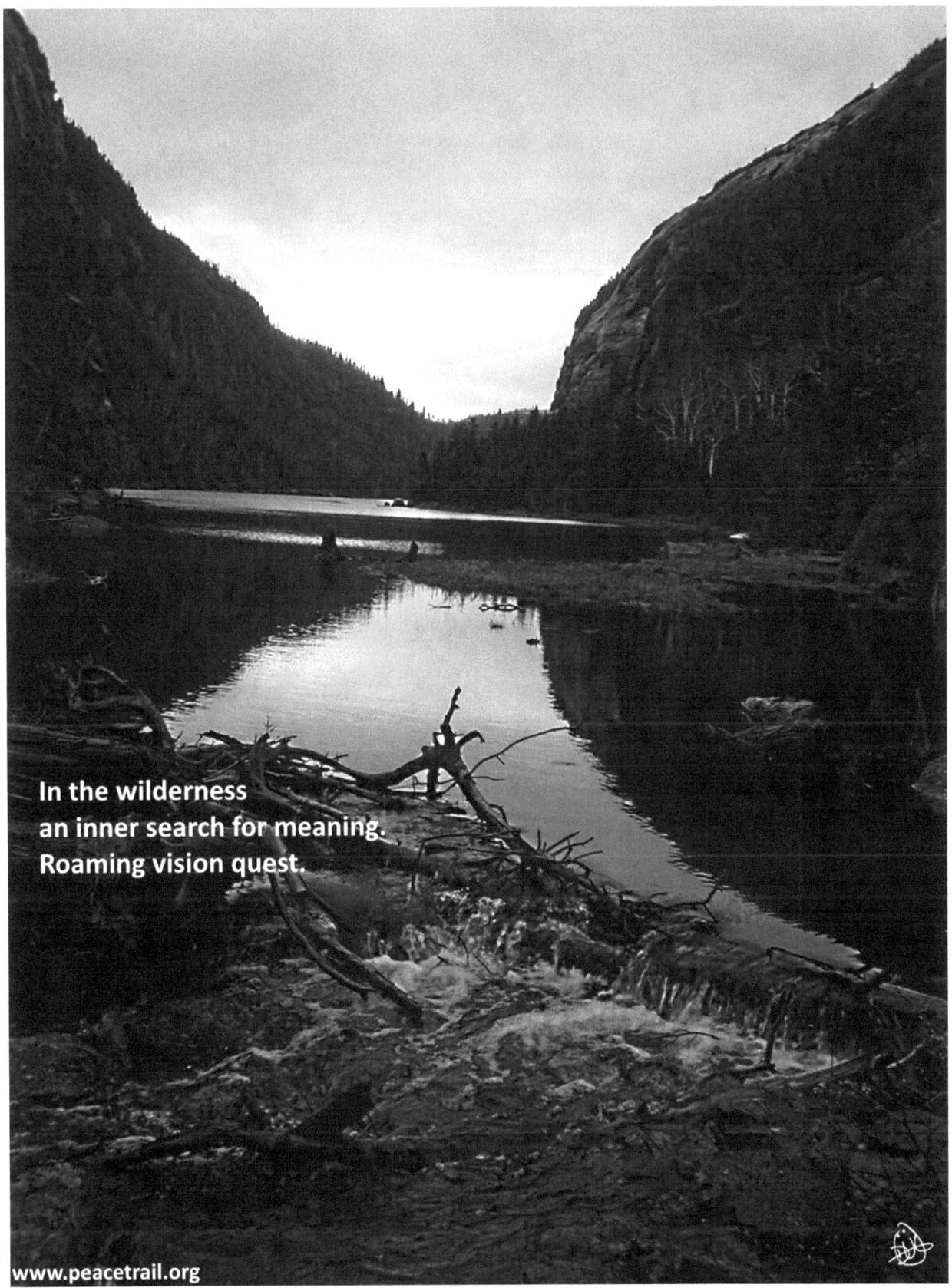

Flowed Lands, Adirondack Park. April, 2003.

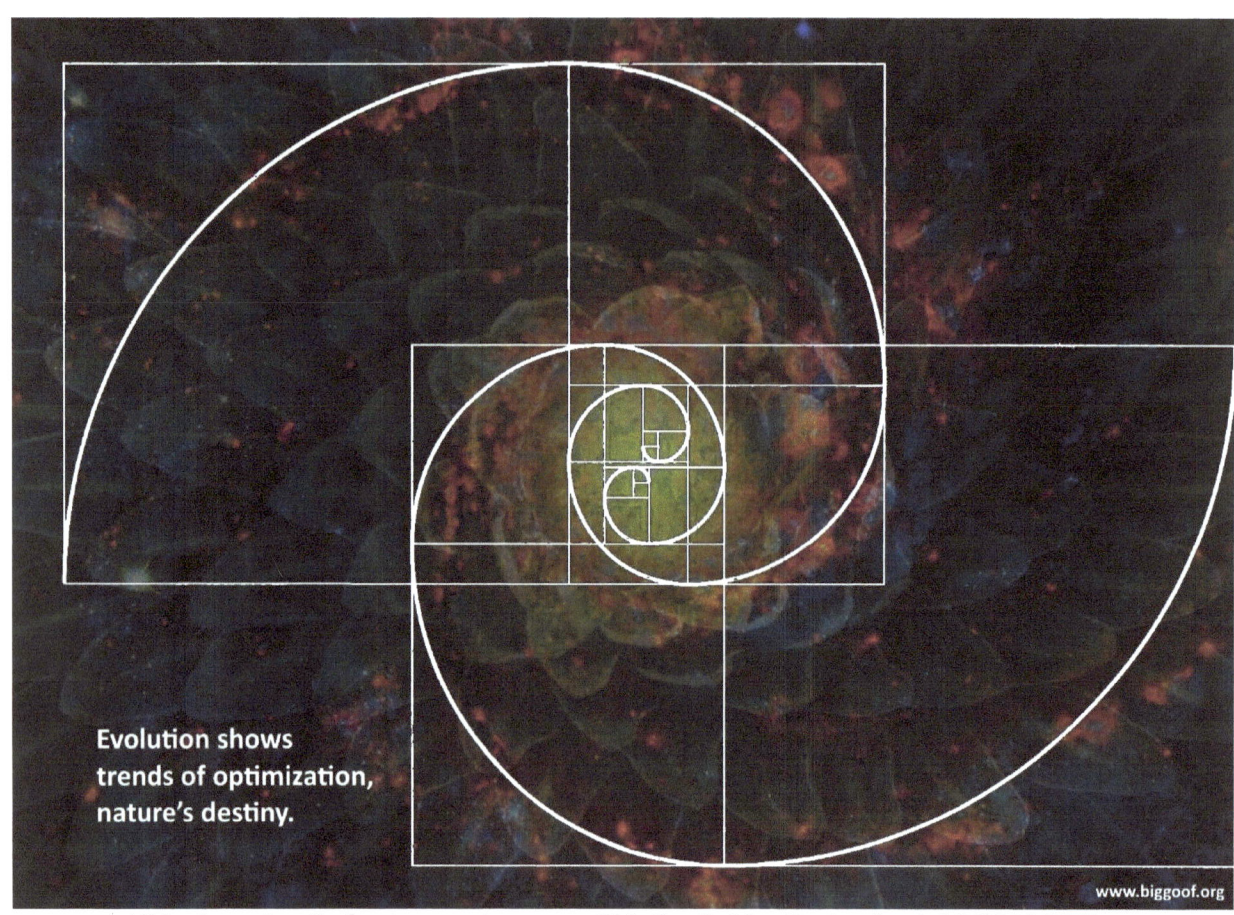

Ubiquitous in all of nature and cosmos, Phi, the Golden Ratio. φ = 1.61803398875...

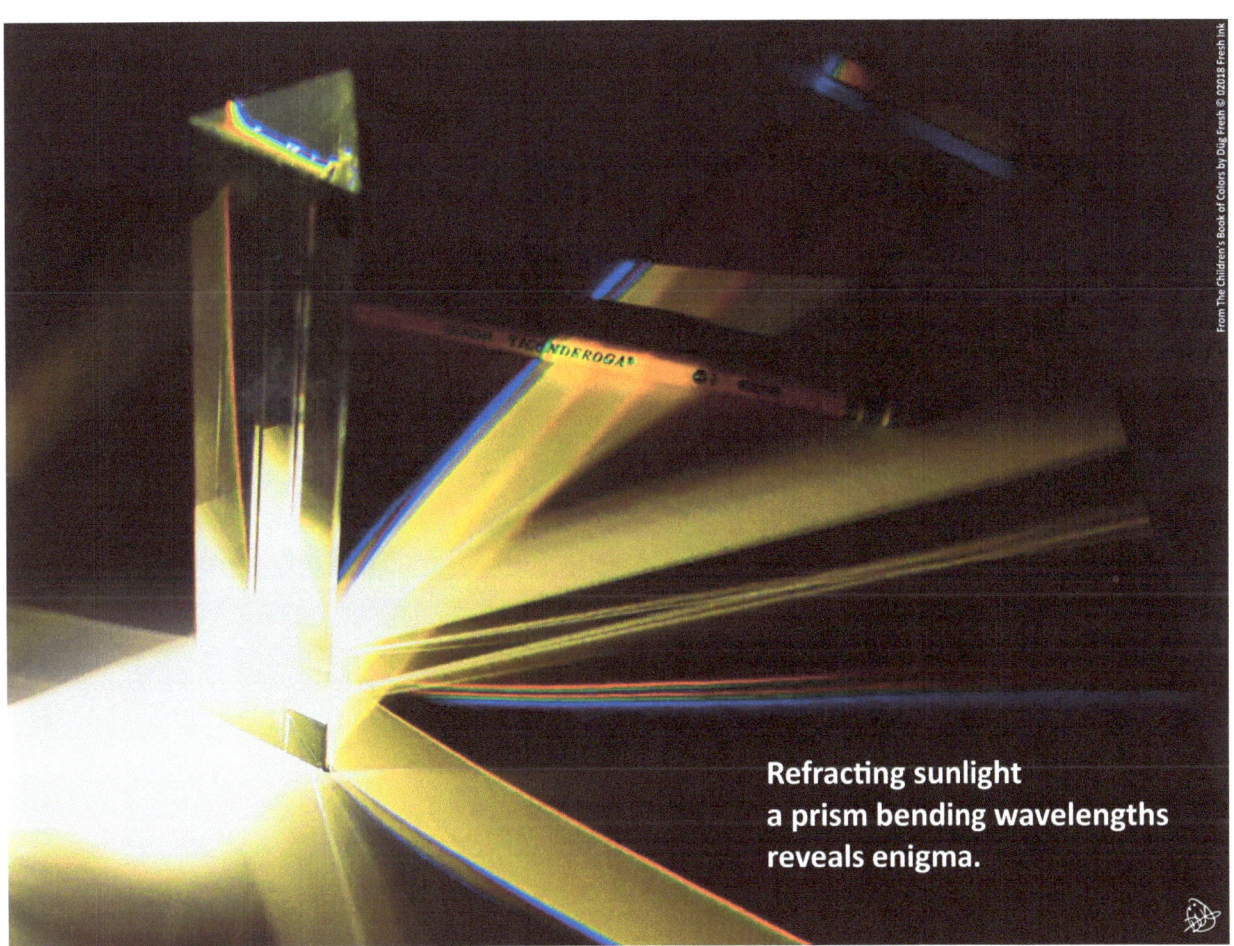

Title track to the new album.

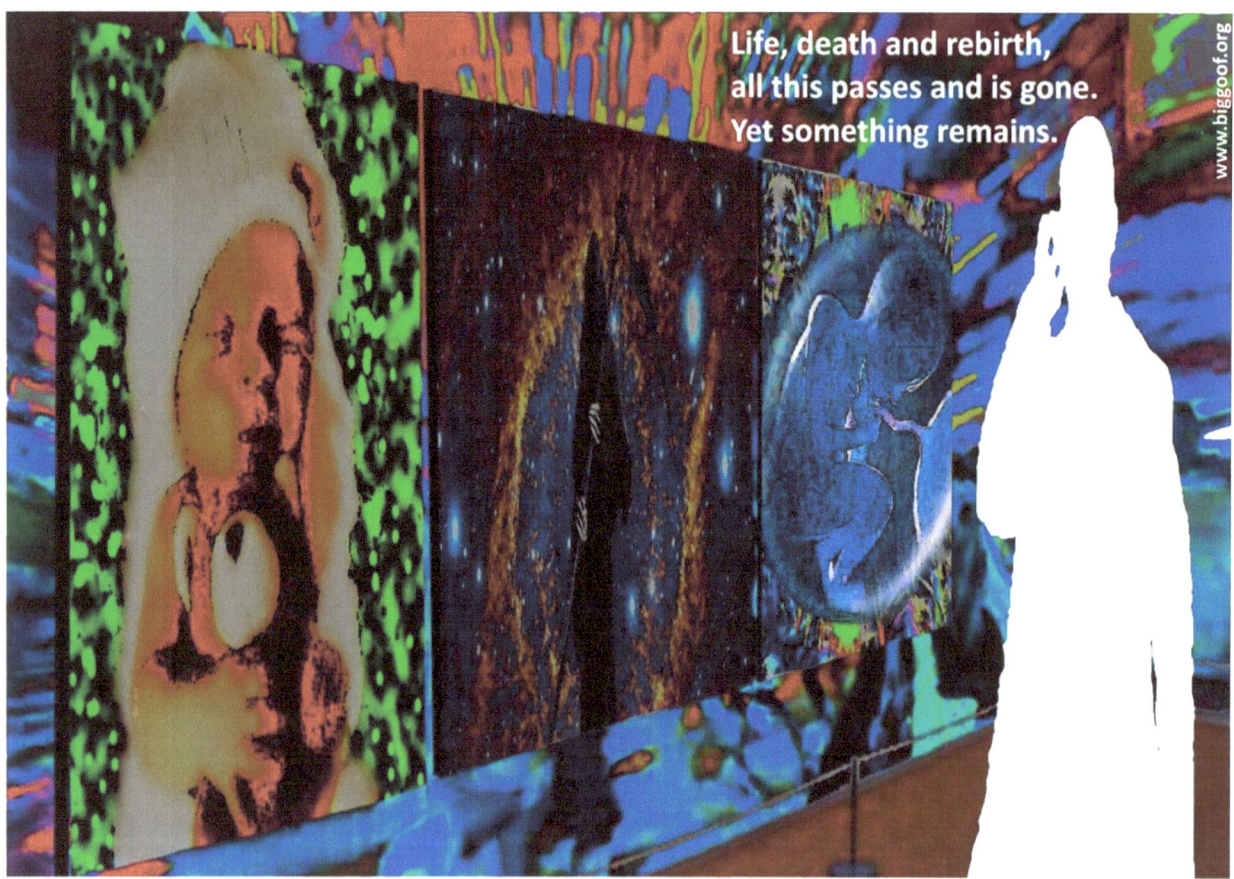

The Jewel in the Lotus. Collage of collages in a collage.

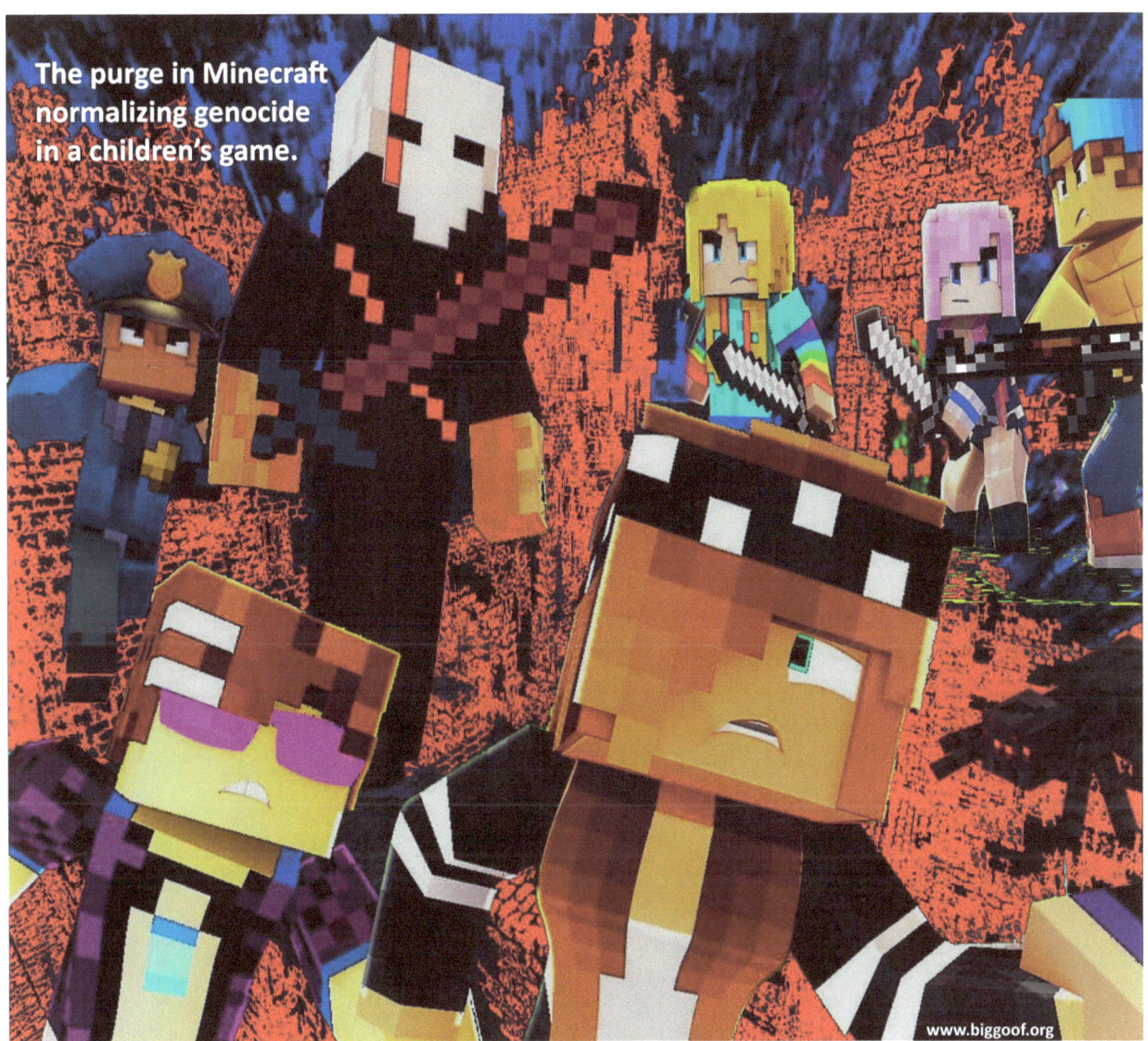

Collage of Internet-found Minecraft objects for social satire and commentary.

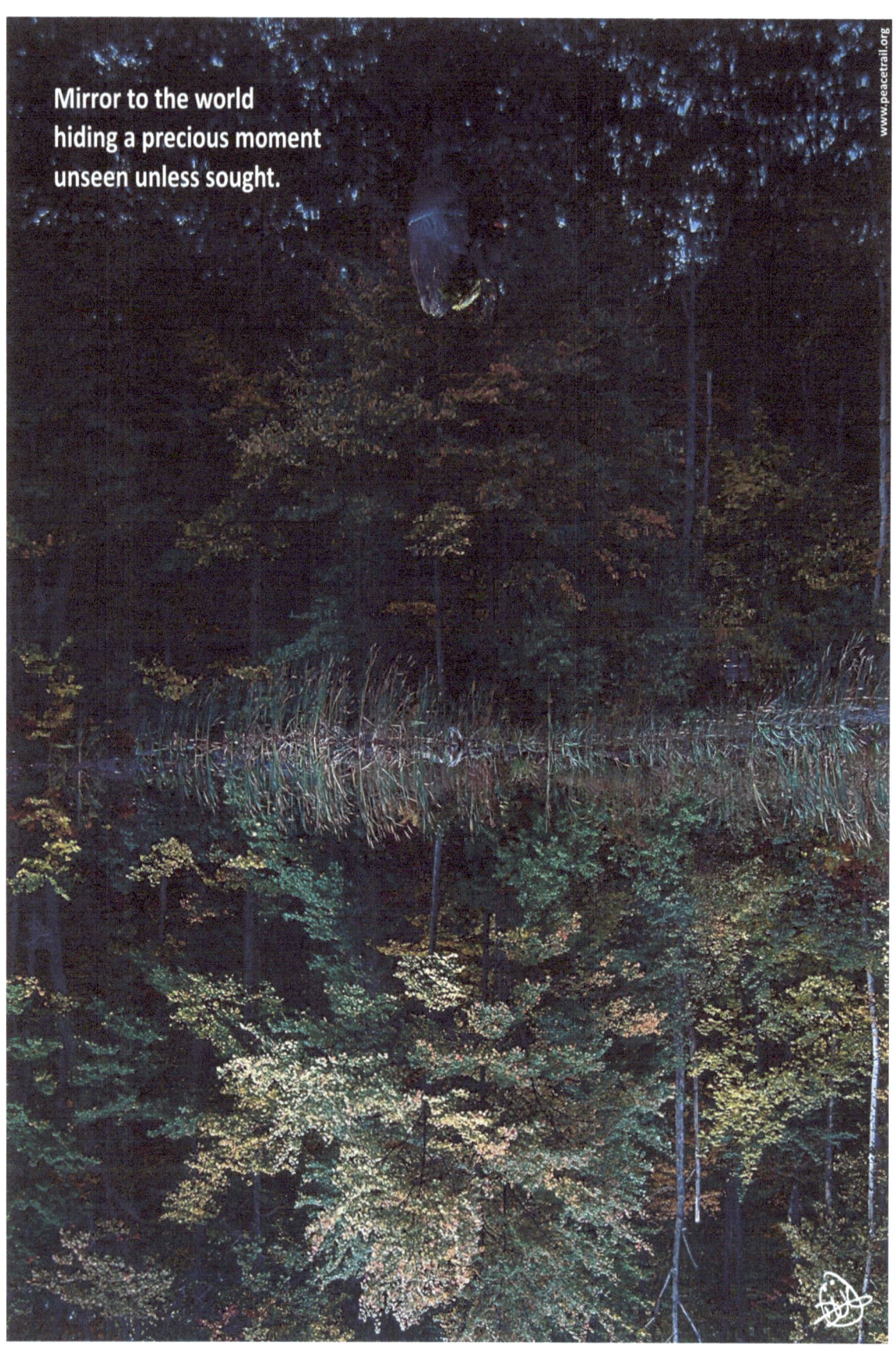

Benedict Pond, Massachusetts. Appalachian Trail, October 7th, 02005.

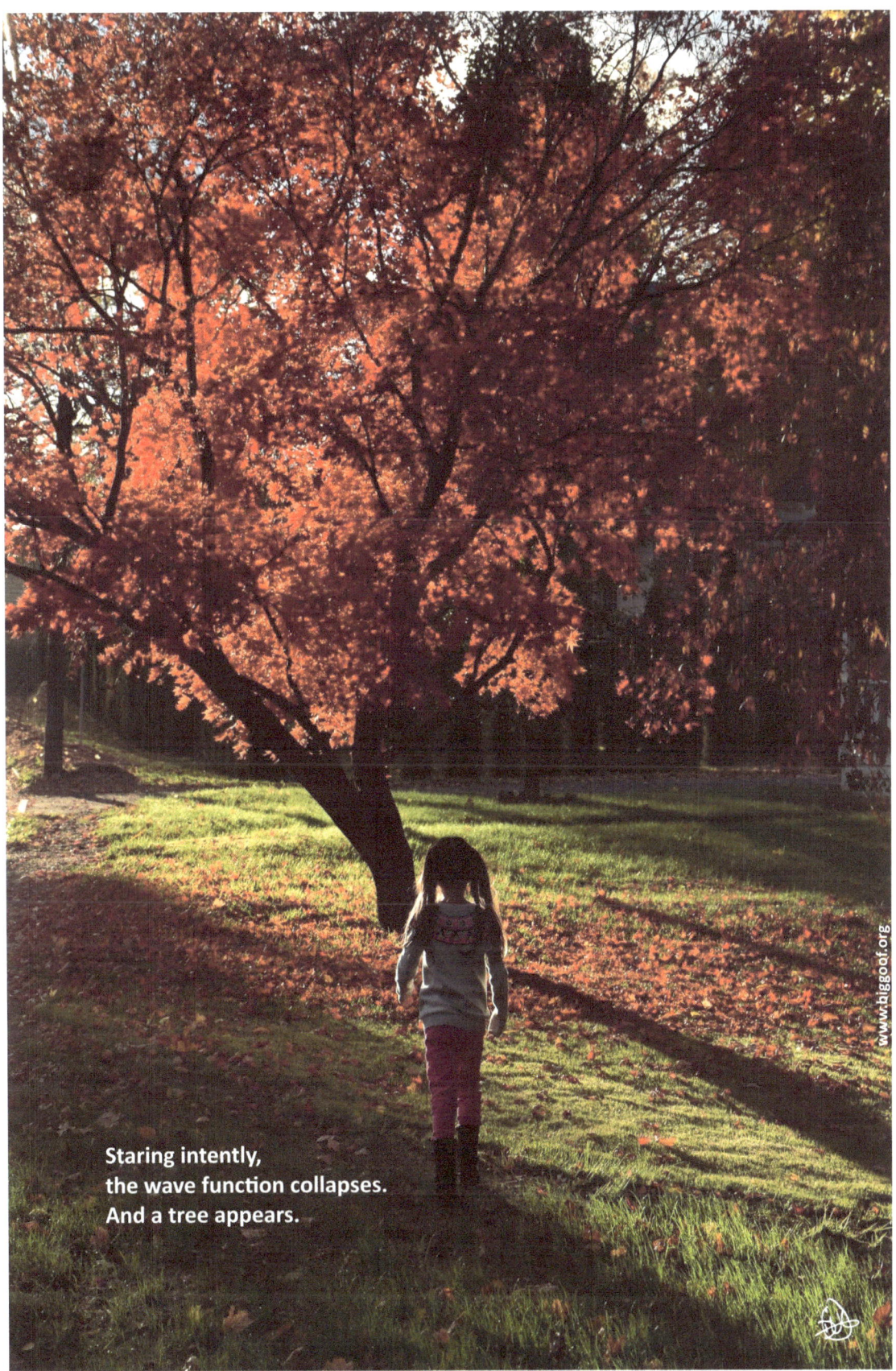

Fall in Upstate. Ballston Spa, NY.

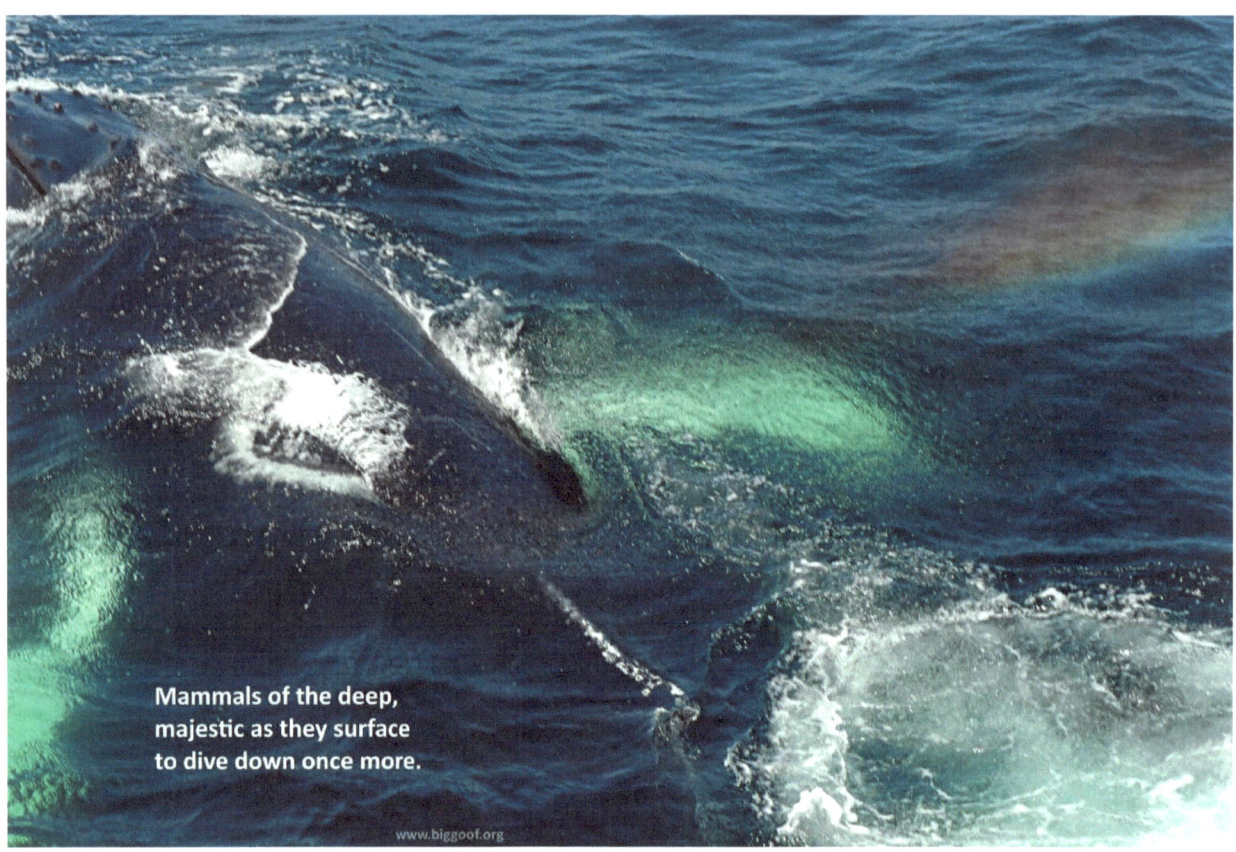

Whale Watch. Cape Cod, Mass.

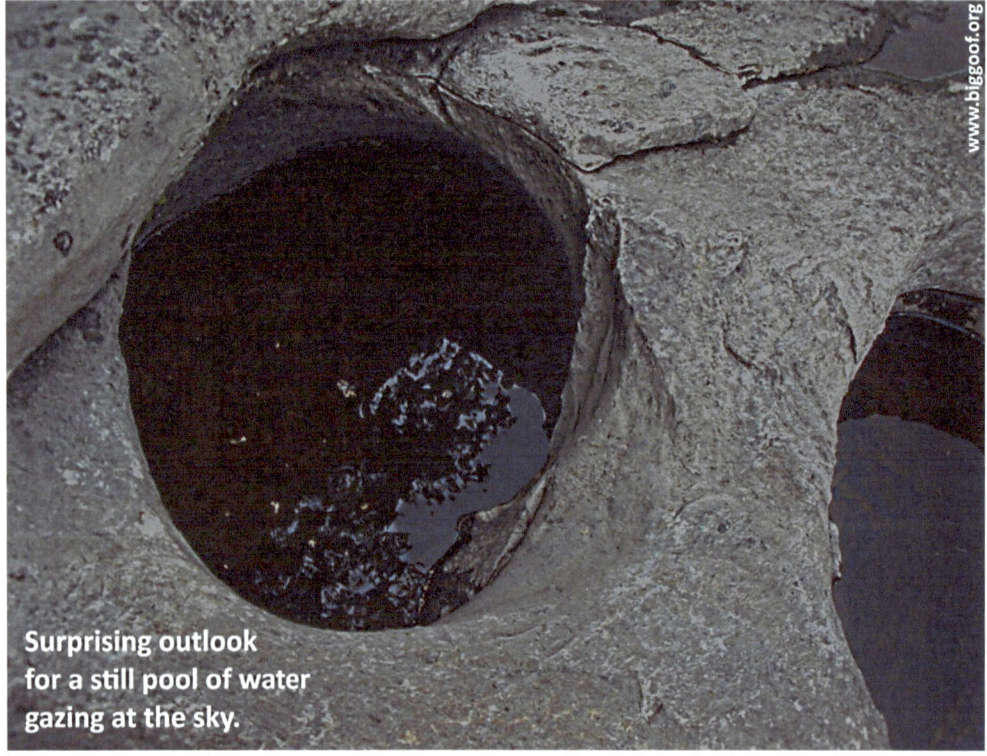

Along the bank of the Housatonic River, Connecticut. Appalachian Trail, May 02008.

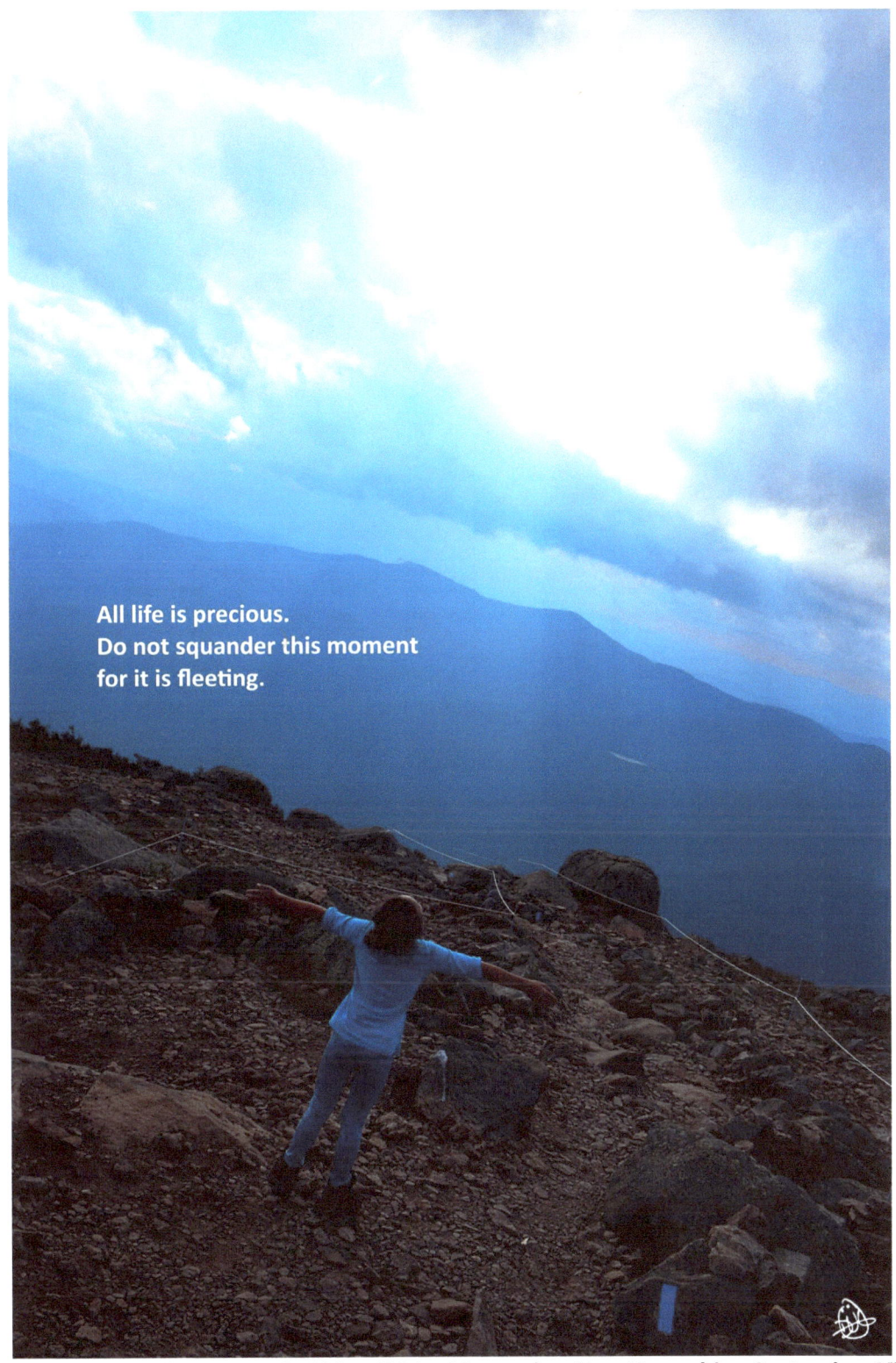

Little Haystack Mountain, Franconia Ridge. White Mountains, New Hampshire. September 3rd, 02018.

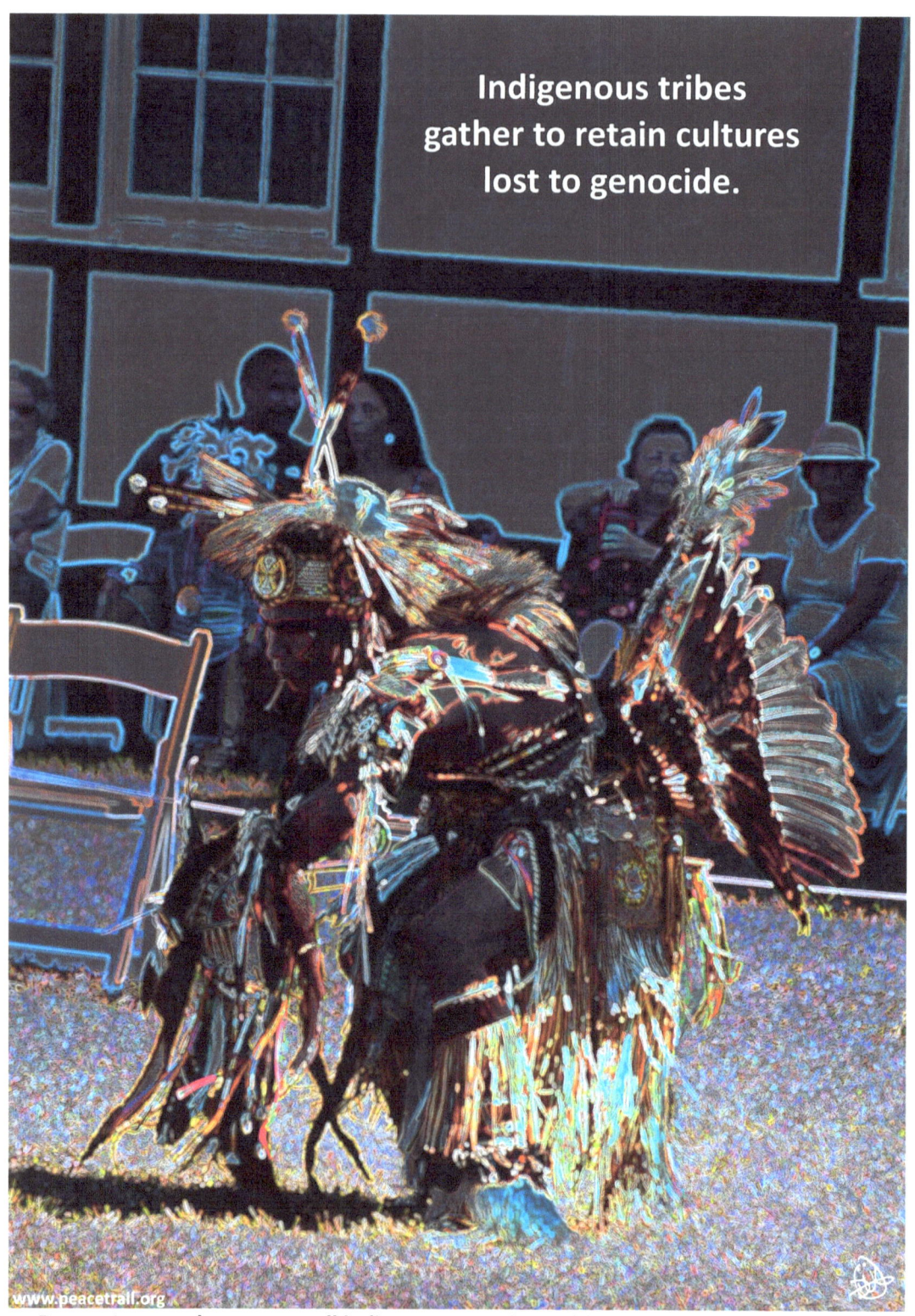

Ghost Dance. Love and respect to all indigenous peoples. Additional Native American Resources[i]

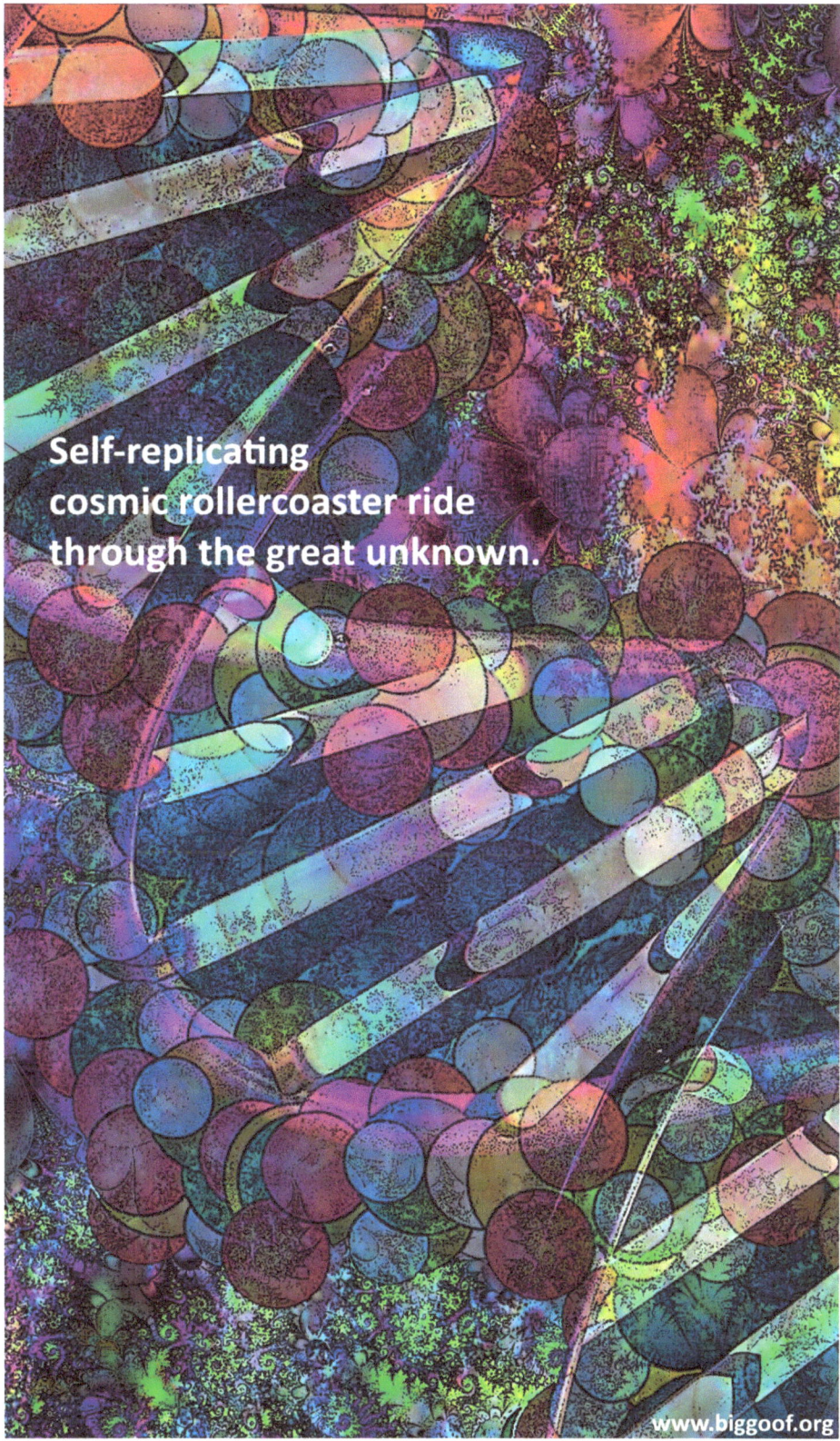

SiMuLaTOR - Super-intelligent Multi-universal Labyrinth-adventuring Temporal Organic Reproduction. Collage.

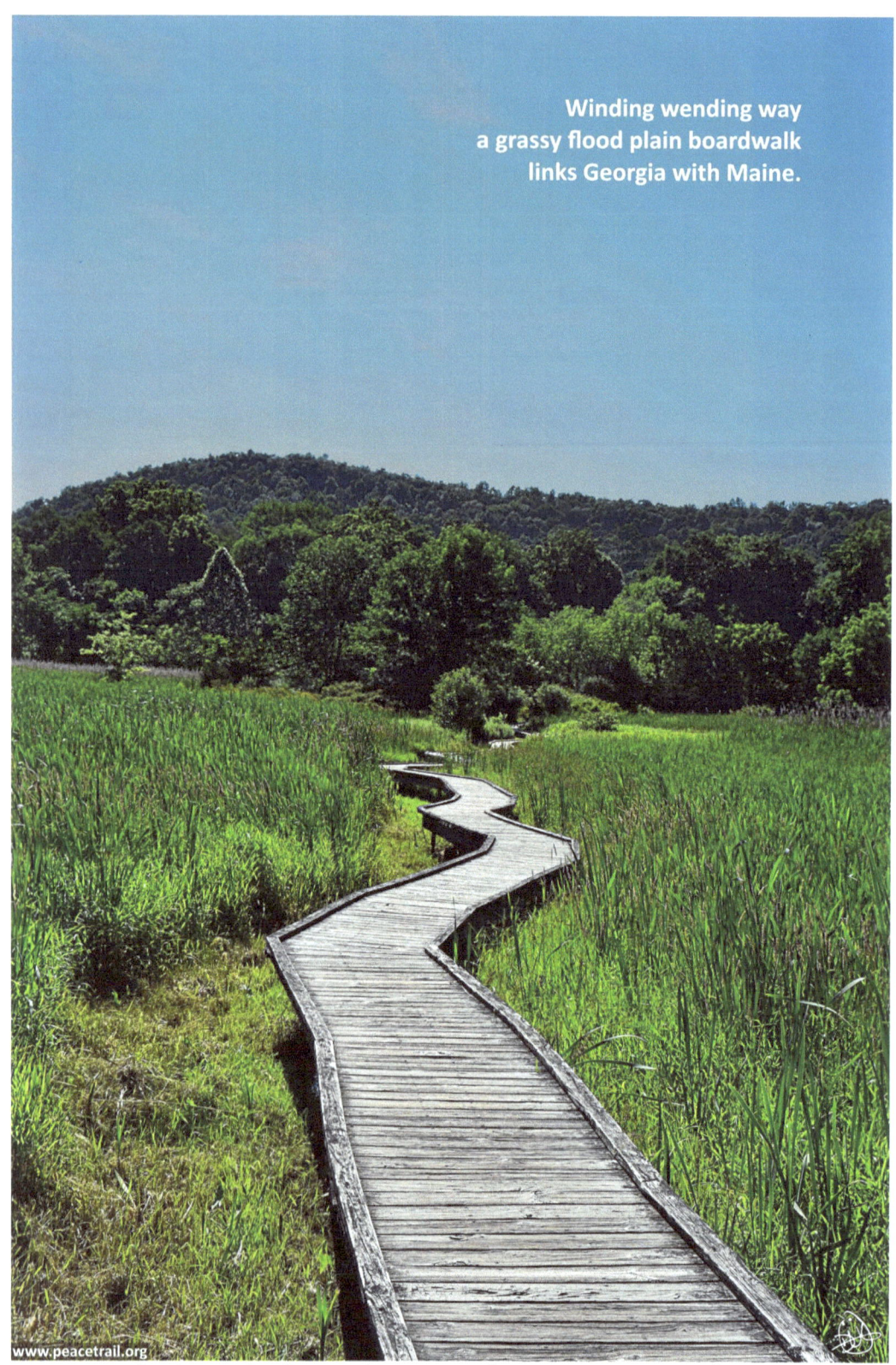

Pochuck Boardwalk. Appalachian Trail[ii], Vernon NJ. June 23rd, 02019.

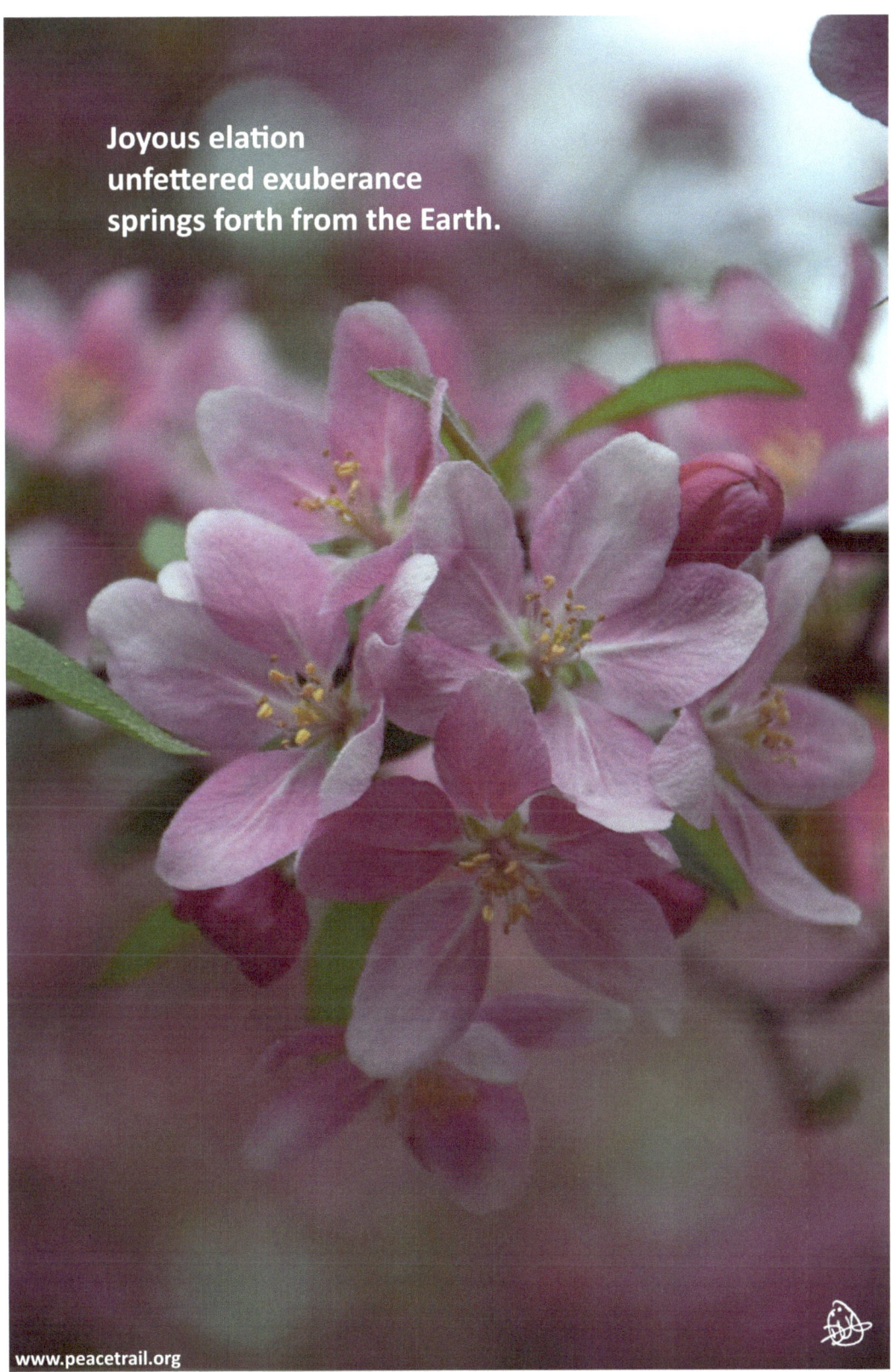

Cherry blossoms. Backyard.

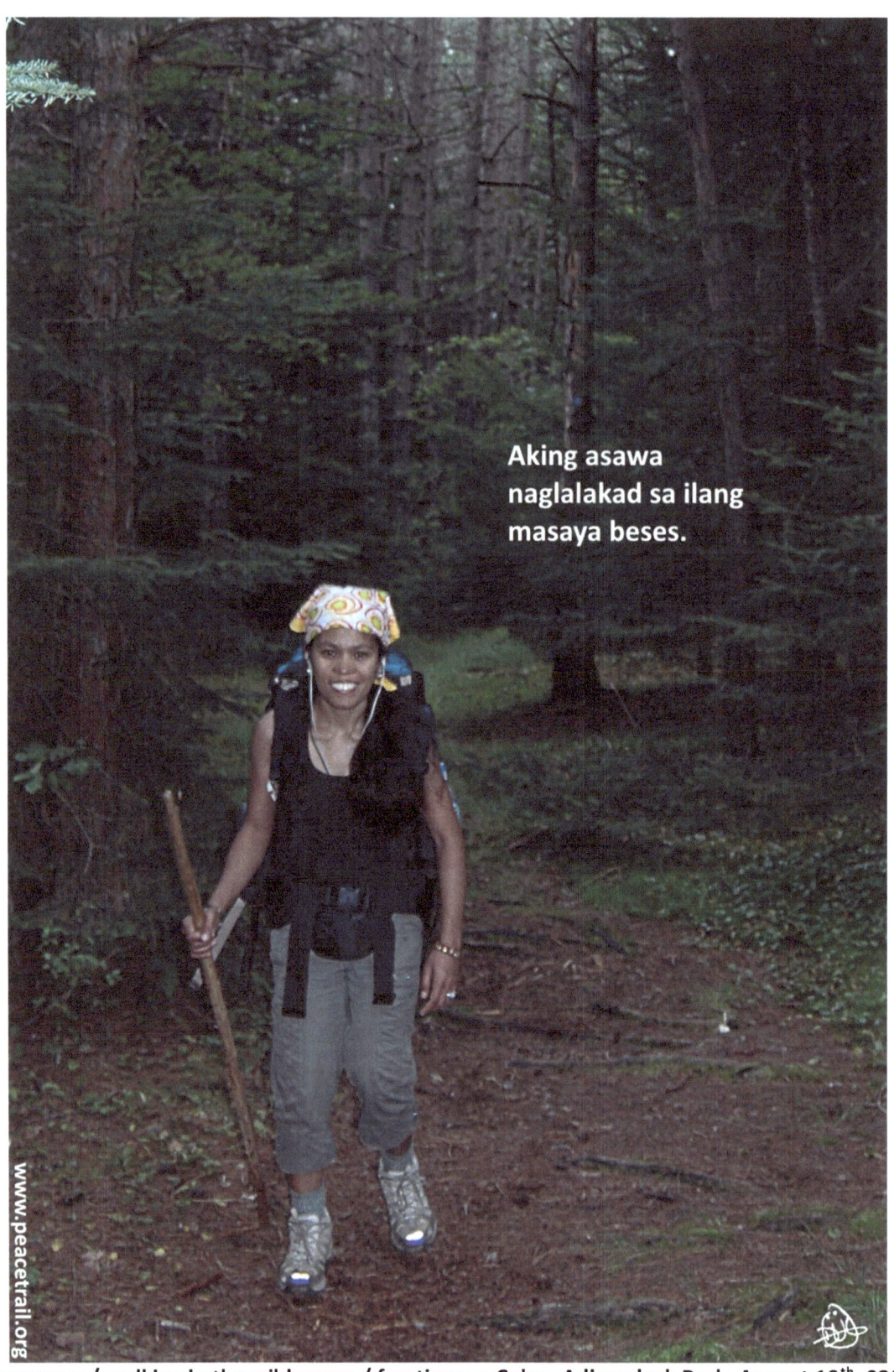

<My spouse / walking in the wilderness / fun times.> Calea. Adirondack Park. August 10th, 02008.

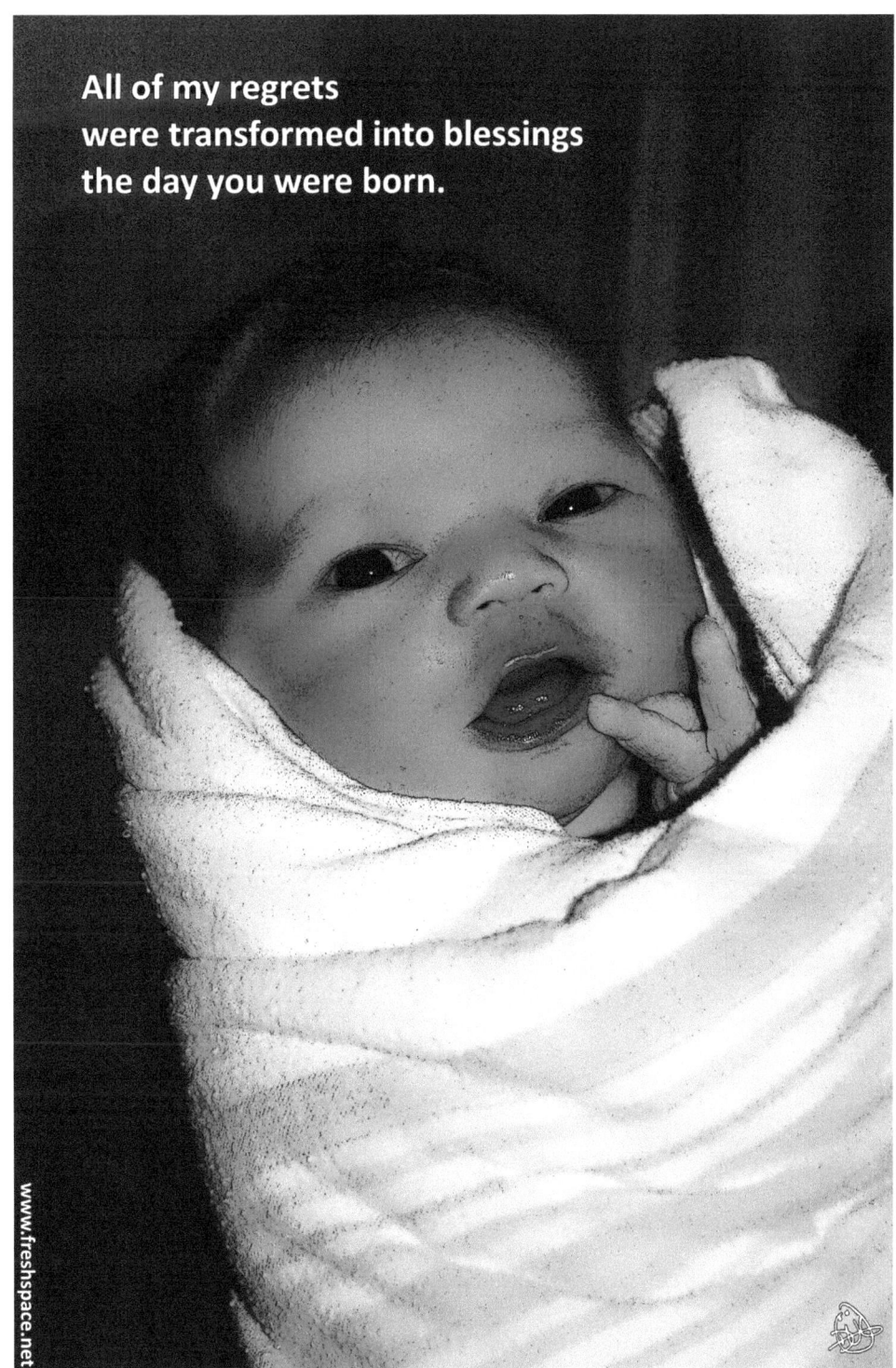

Marcelina. 33-minutes old. November 1st, 02009, 10:51 PM.

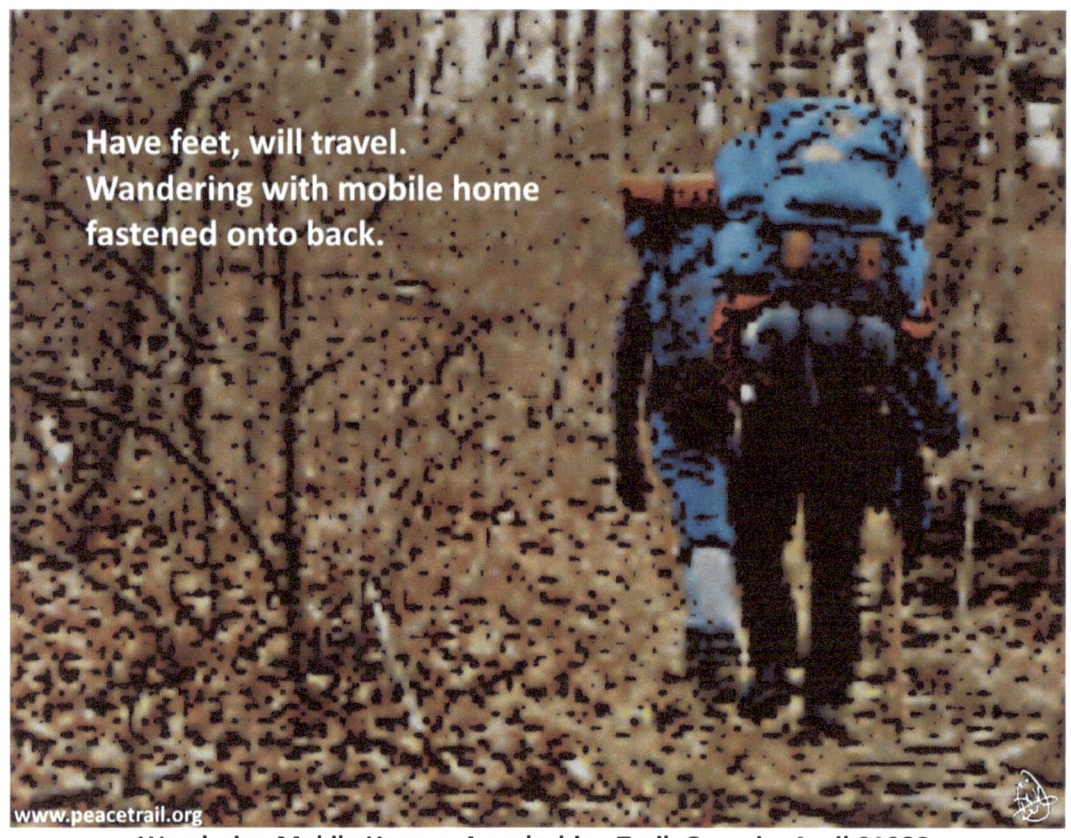
Wandering Mobile Homes. Appalachian Trail, Georgia. April 01988.

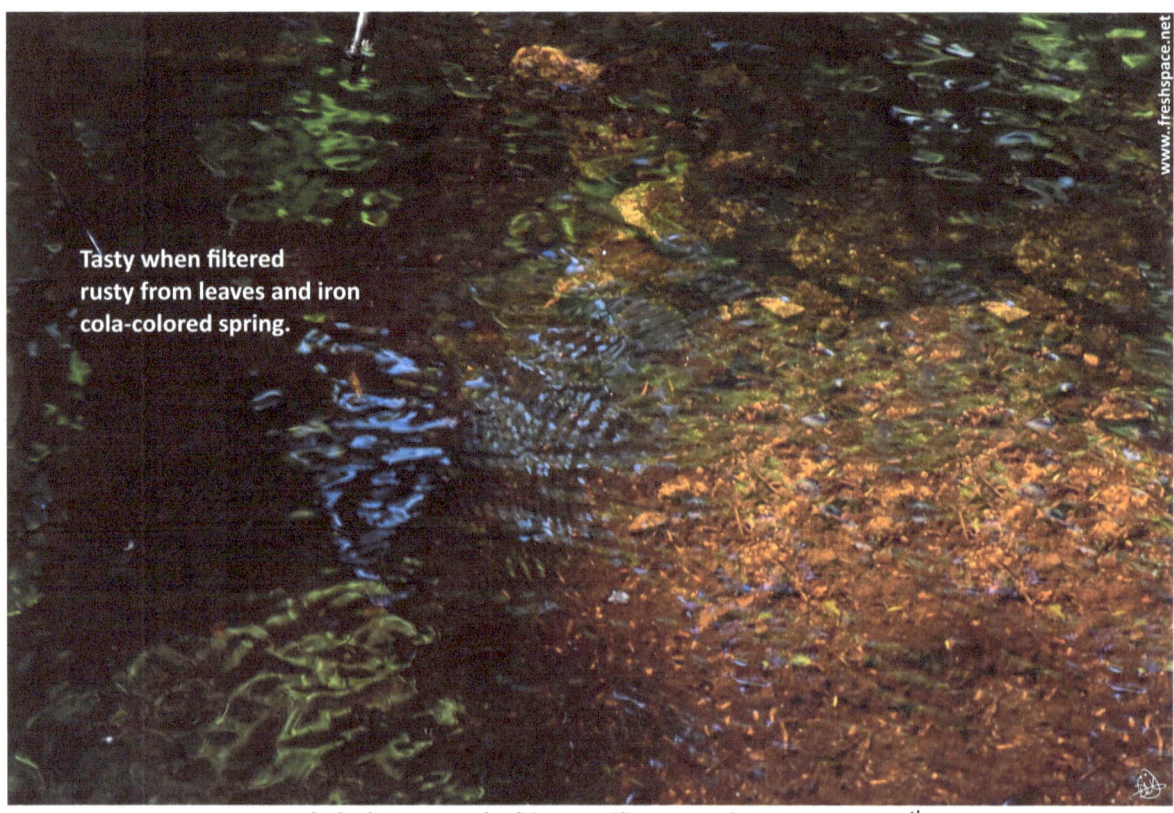
Tom Leonard Shelter, Appalachian Trail, Massachusetts. June 9th, 02019.

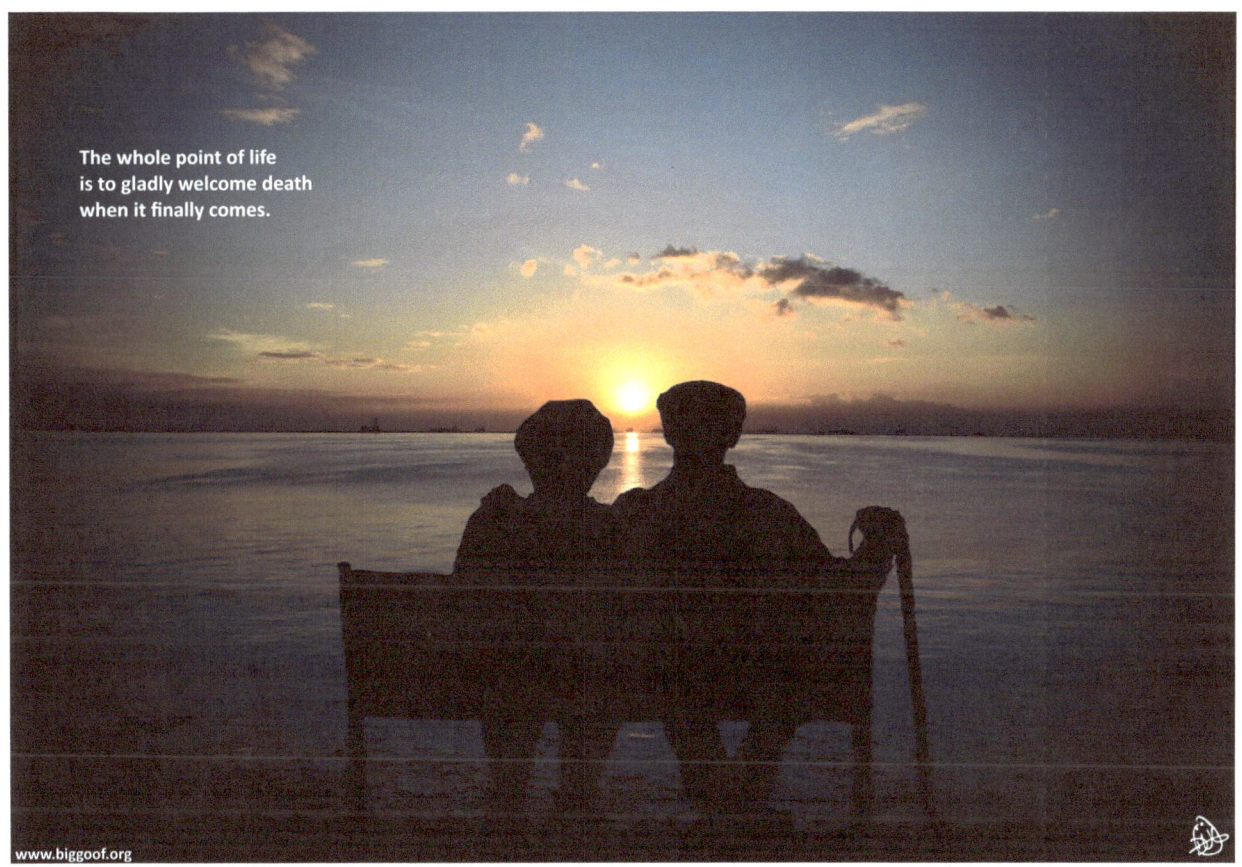

No regrets. Collage. Sunset. Manila Bay, Philippines. January 7th, 02015.

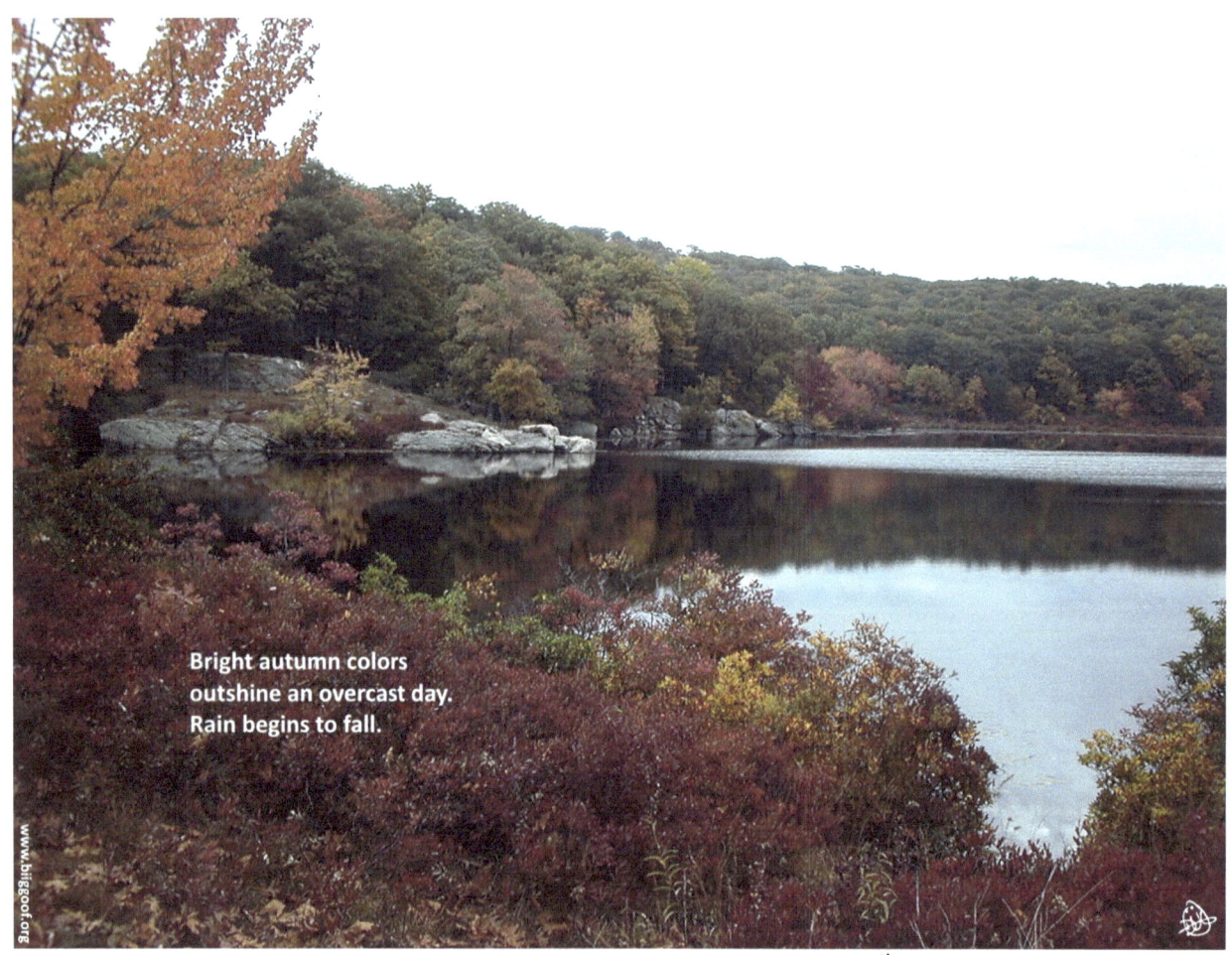

Island Pond, Appalachian Trail, New York. October 14th, 02004.

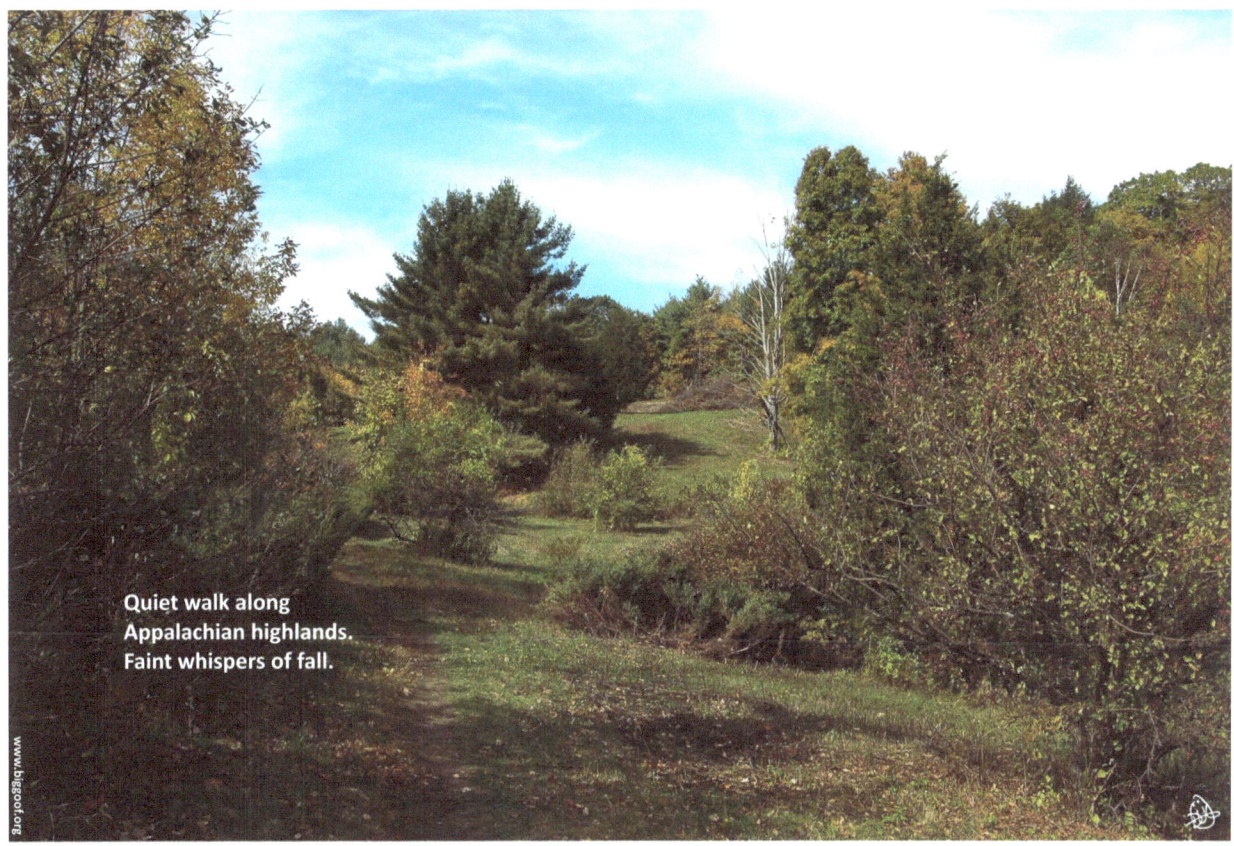

Baldy Mountain, Appalachian Trail, Massachusetts. October 21ˢᵗ, 02005.

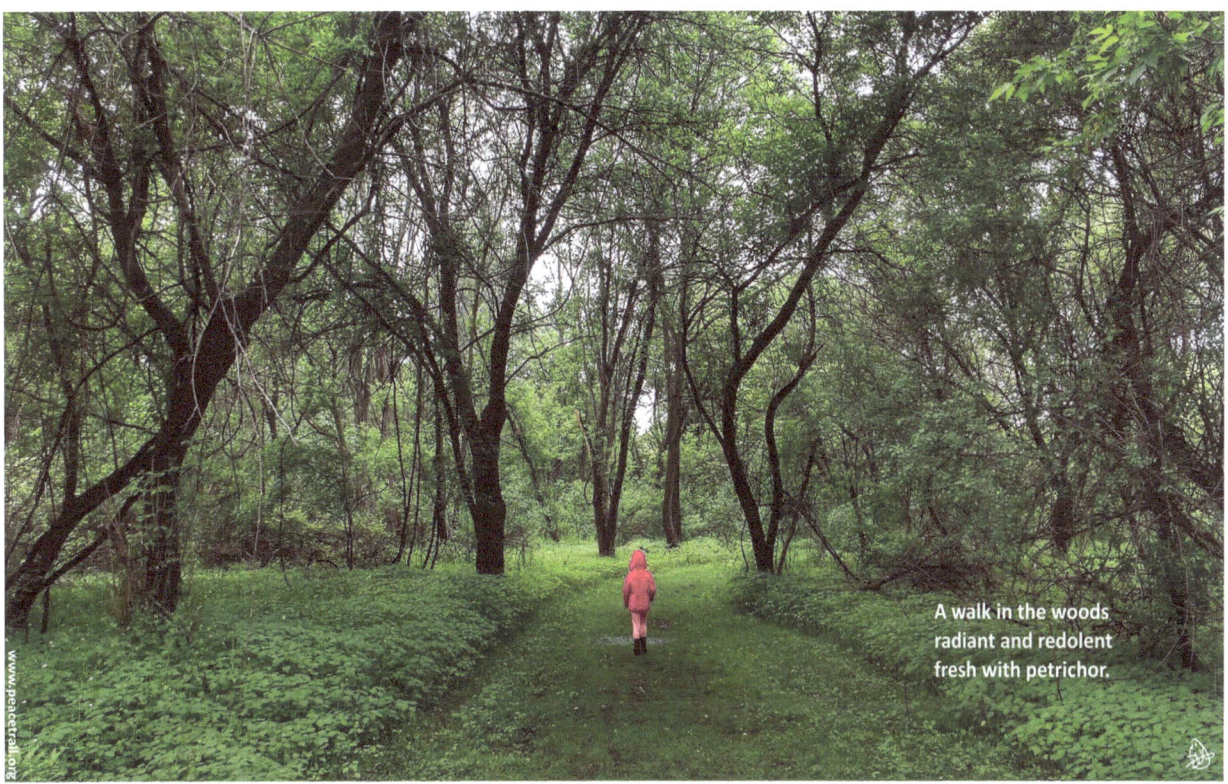

Great Flats Nature Trail, Schenectady, NY. May 29ᵗʰ, 02017.

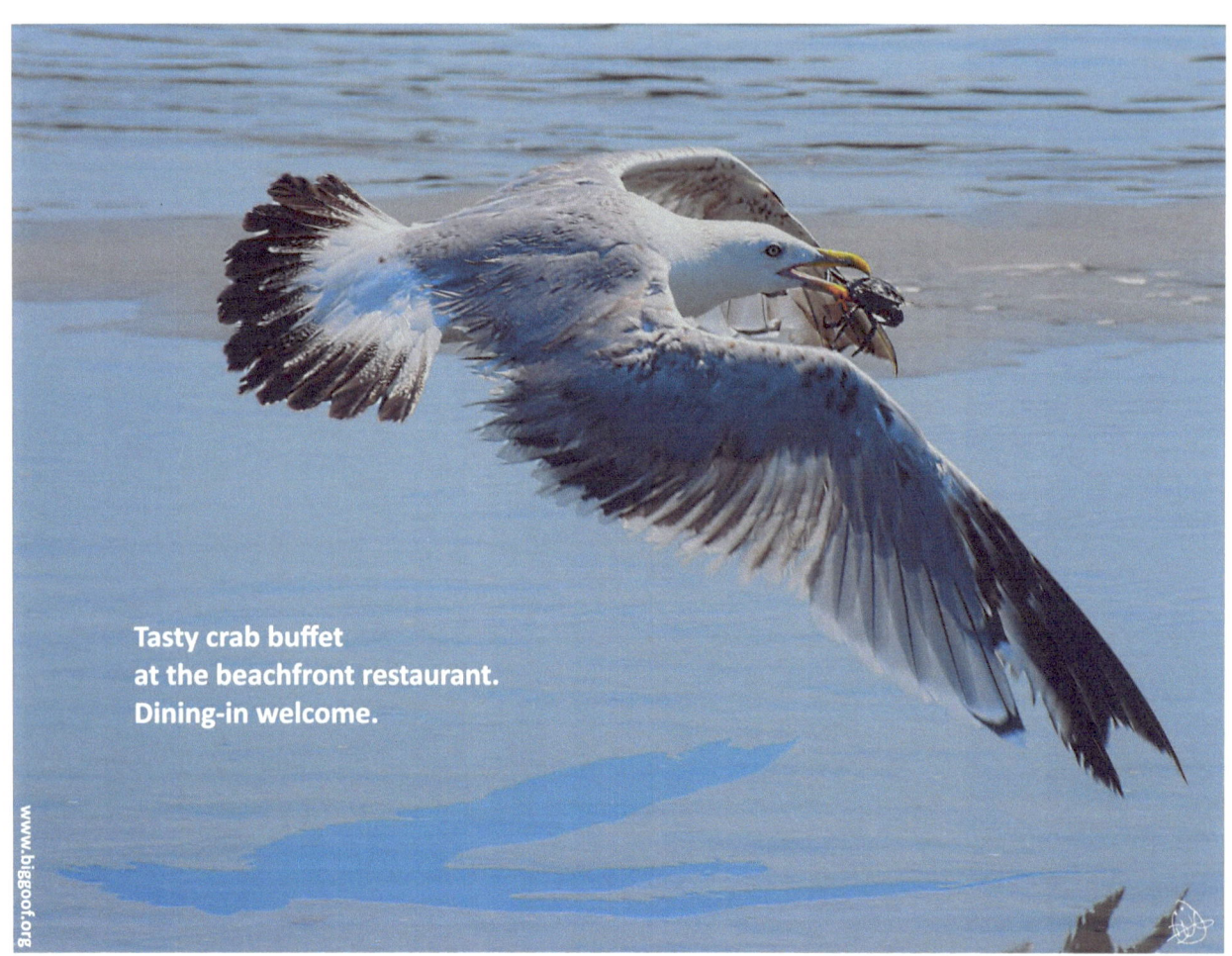

Wingaersheek Beach, West Gloucester, Massachusetts. August 5th, 02018.

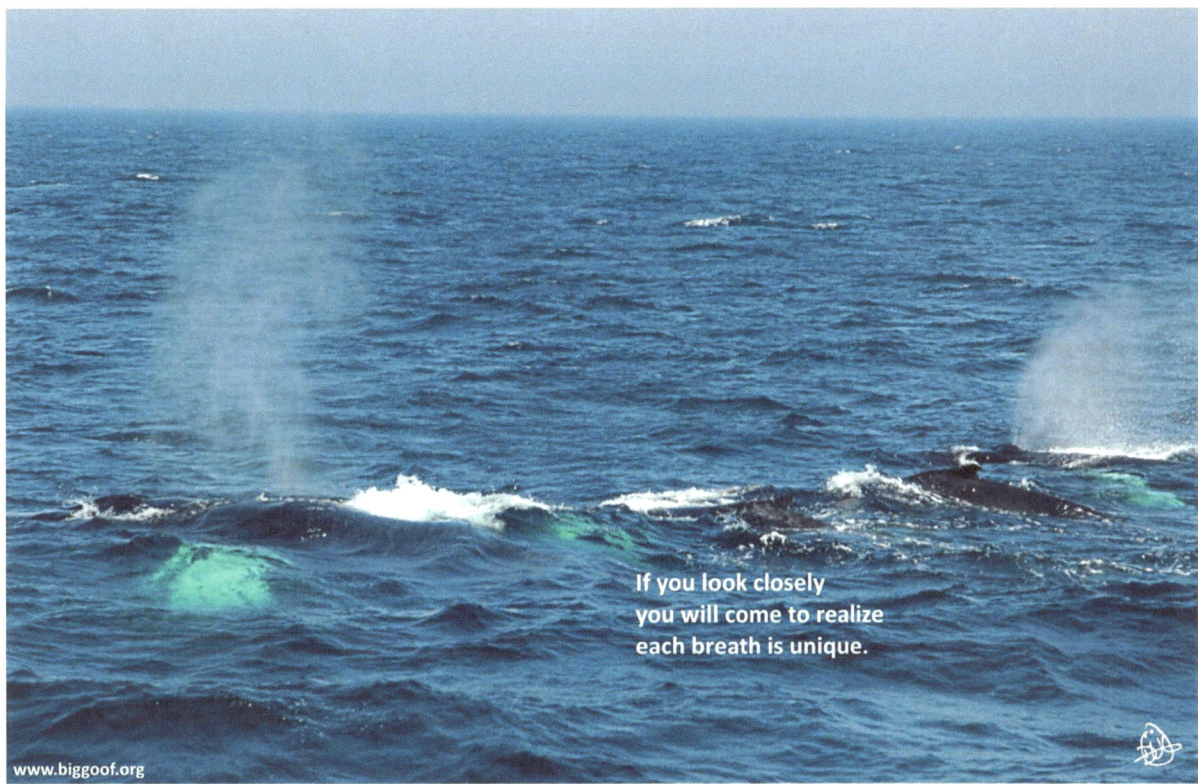
Whale watching, Cape Cod, Massachusetts. September 5th, 02008.

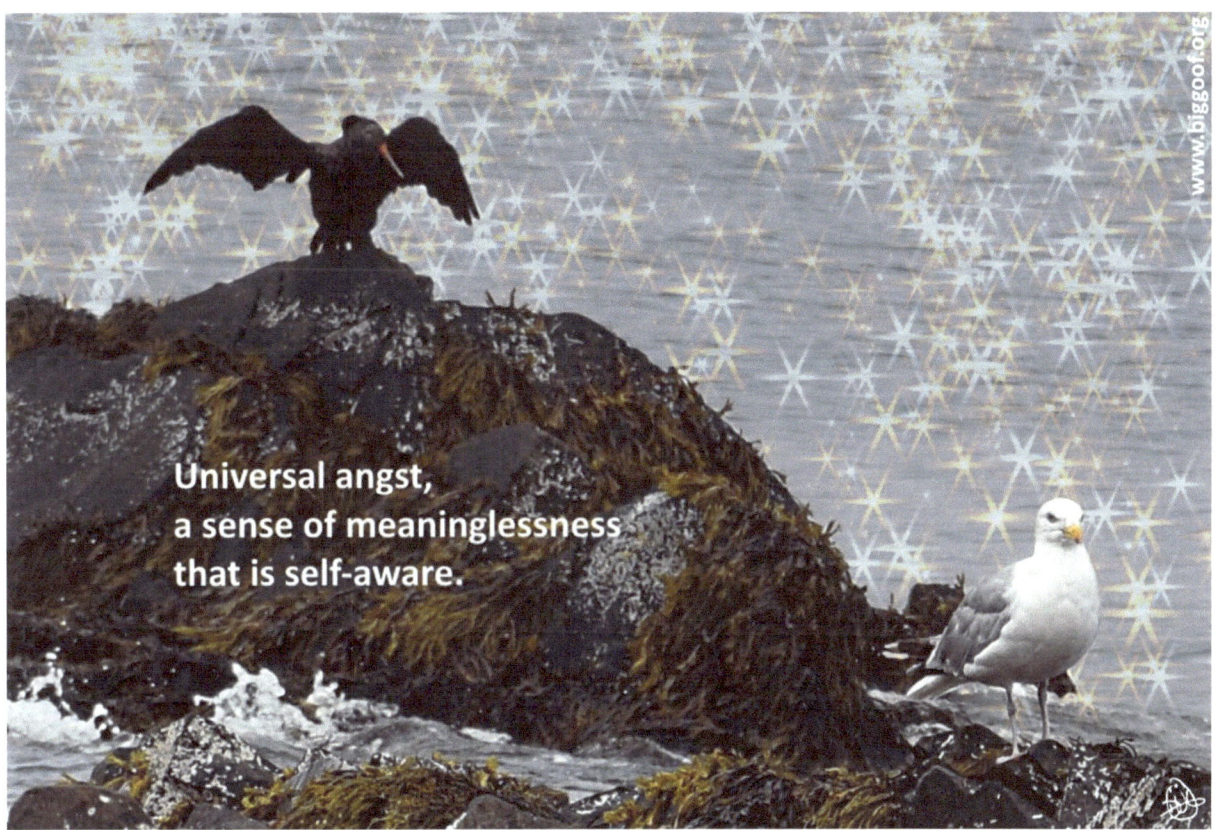
Collage. Owls Head, Maine. August 24th, 02017.

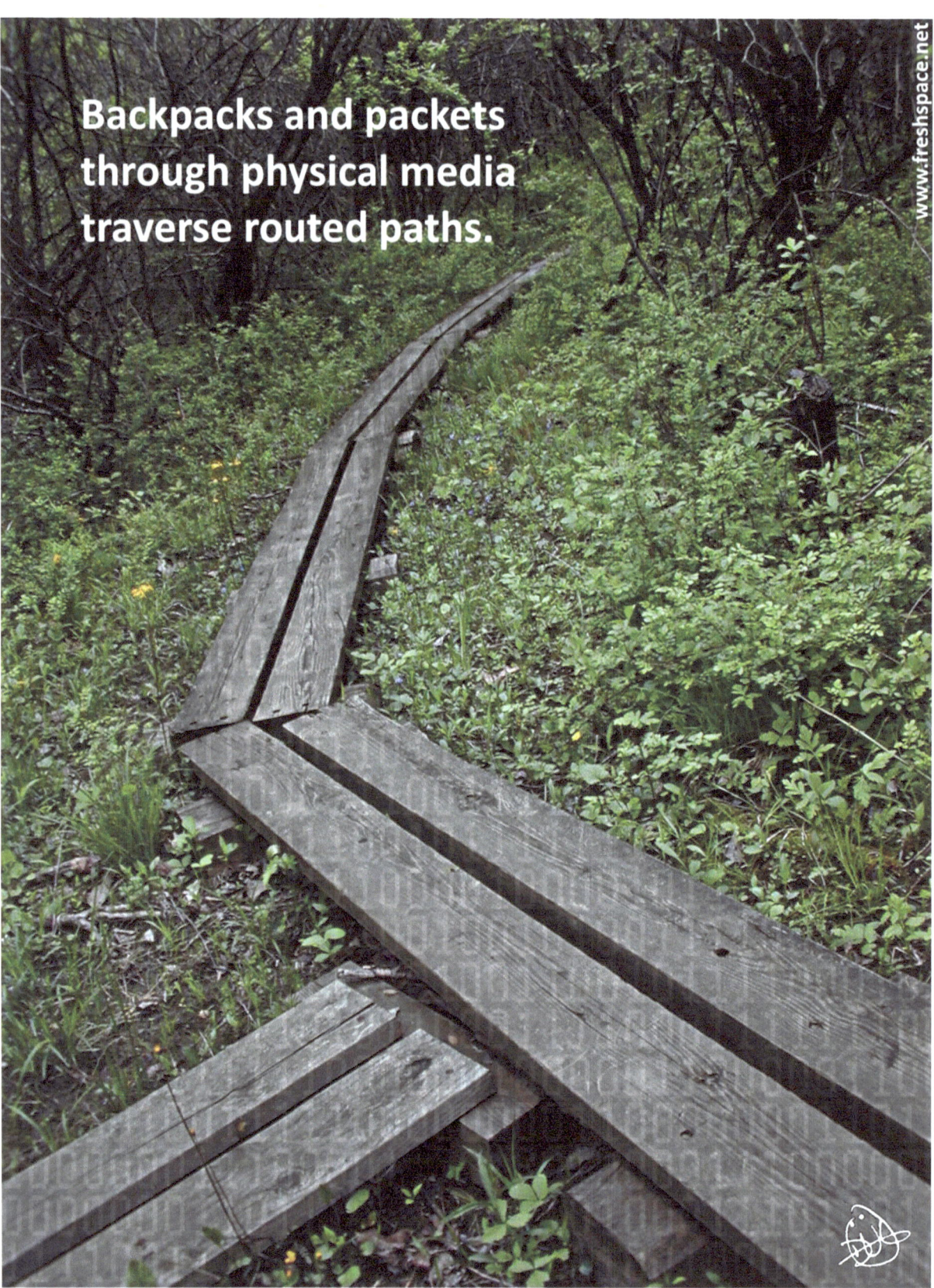

Hammersly Ridge, Appalachian Trail, NY. May 23rd, 02005.

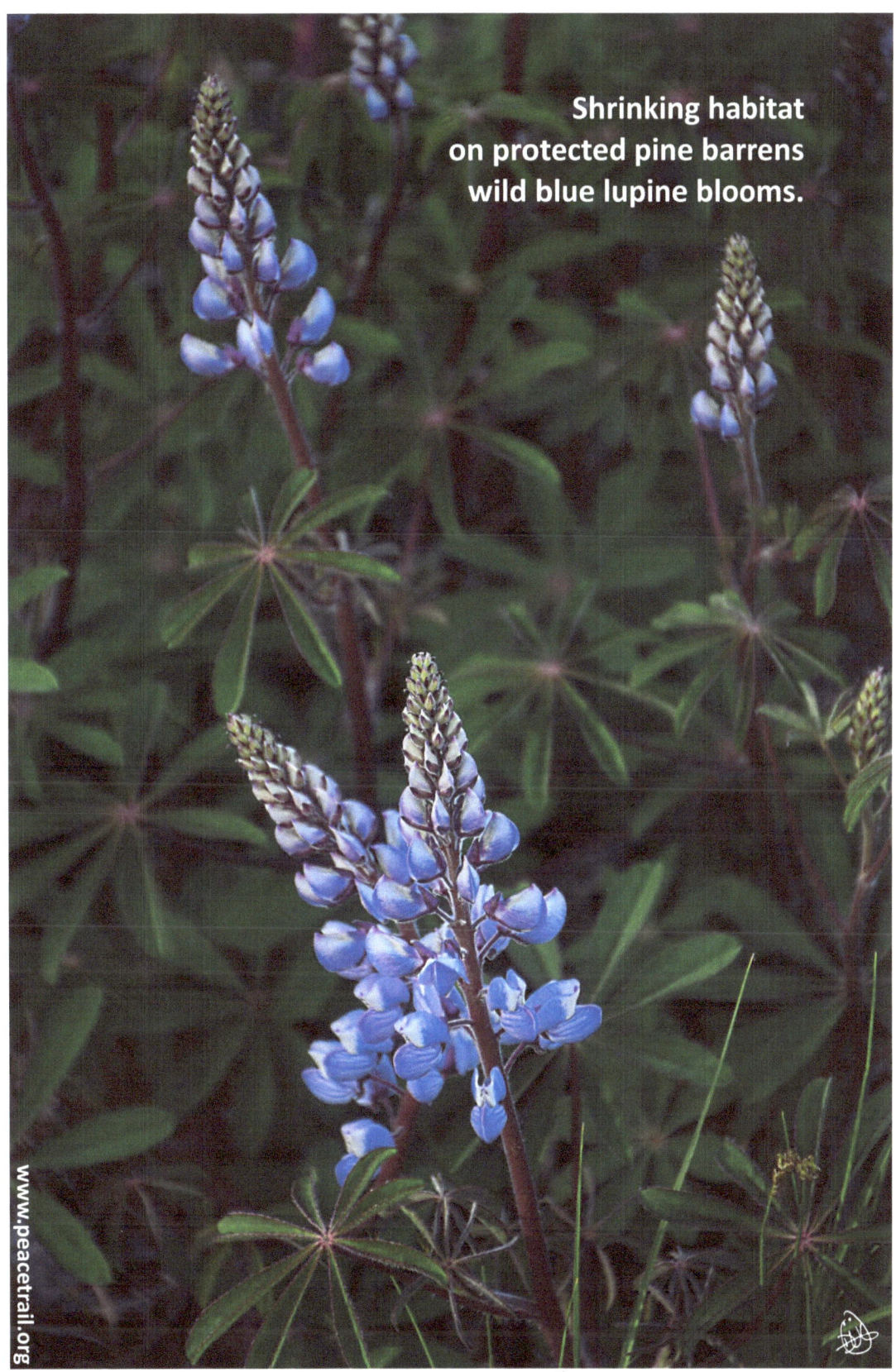

Pine Bush, Albany NY. May 20th, 02018.

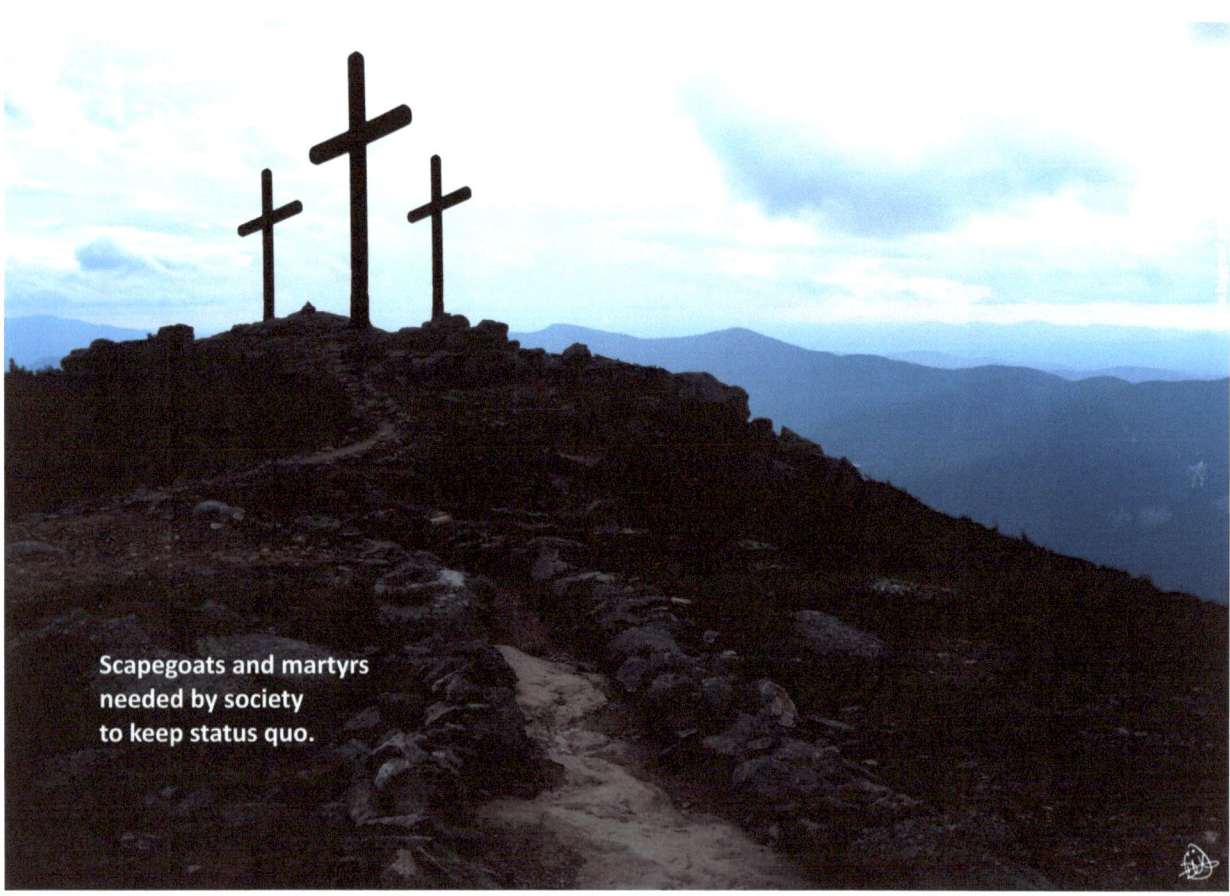

The crucifixion of Jesus upsets the mechanism of sacrificial violence by clearly stating that Jesus was innocent and without sin. Not just an innocent victim but the Son of God was wrongly put to death.

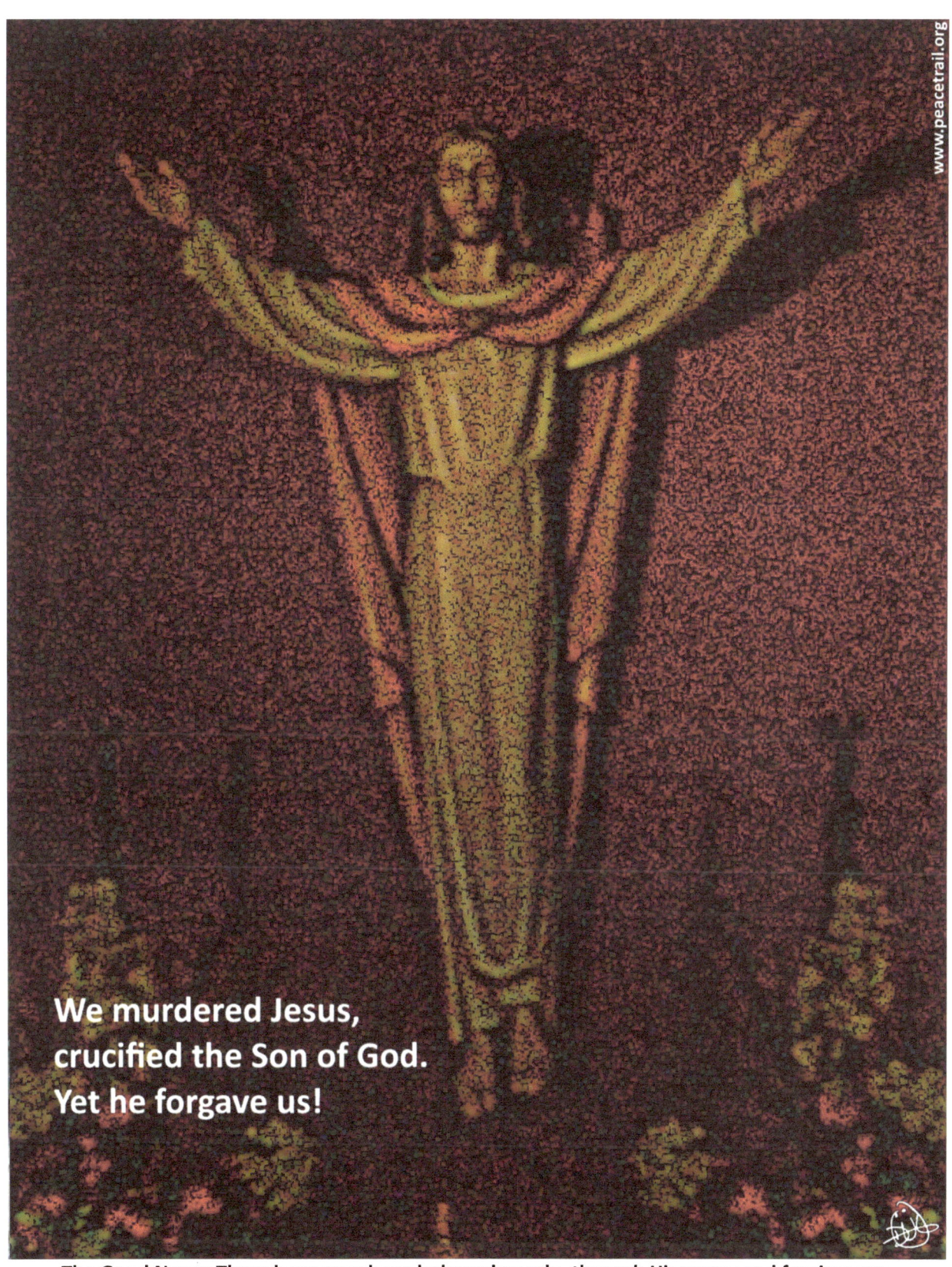

The Good News: Though we may have behaved poorly, through His mercy and forgiveness, we may yet find redemption.

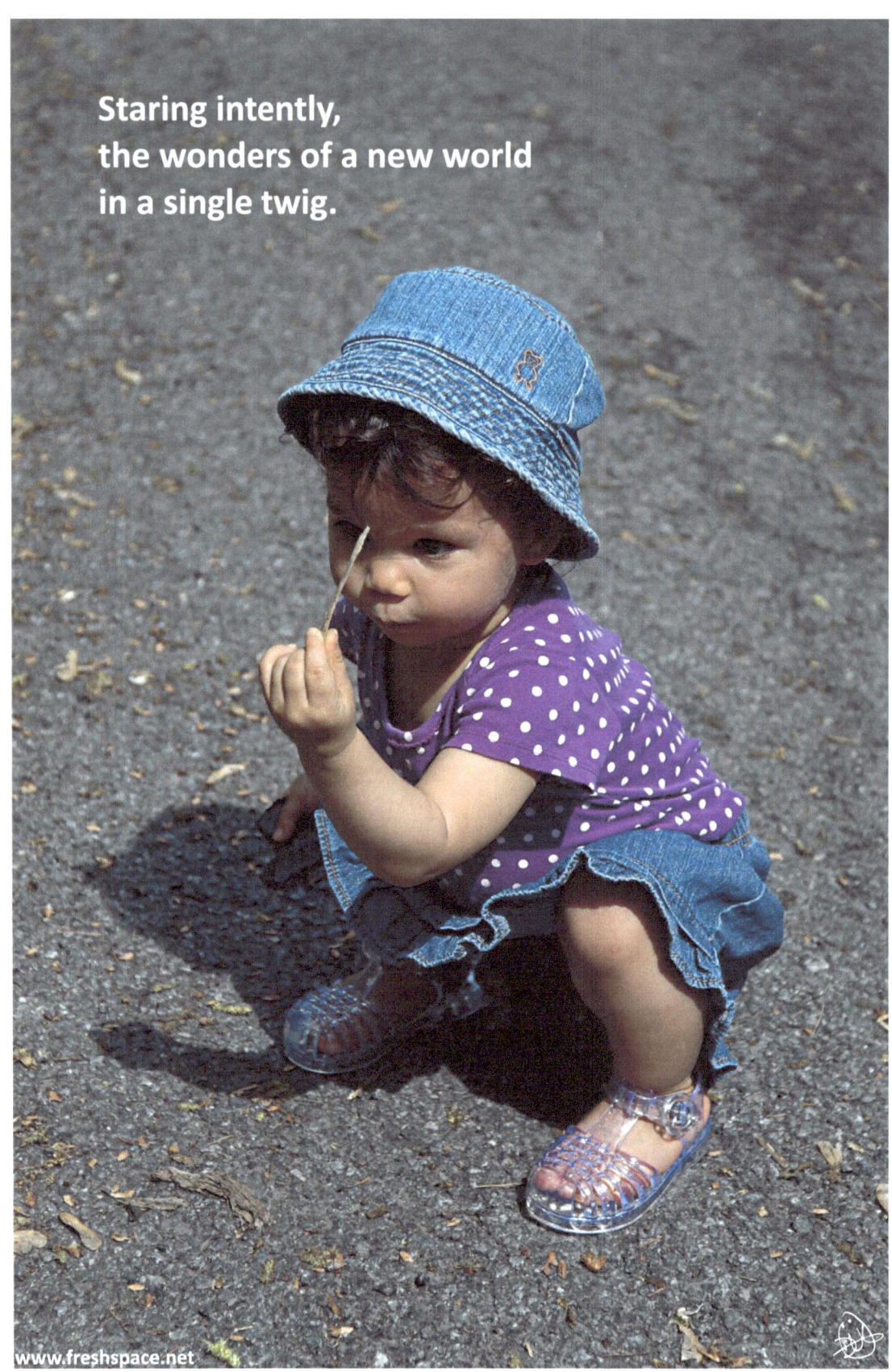

Staring intently. Marcelina, 18-months old. May 28th, 02011.

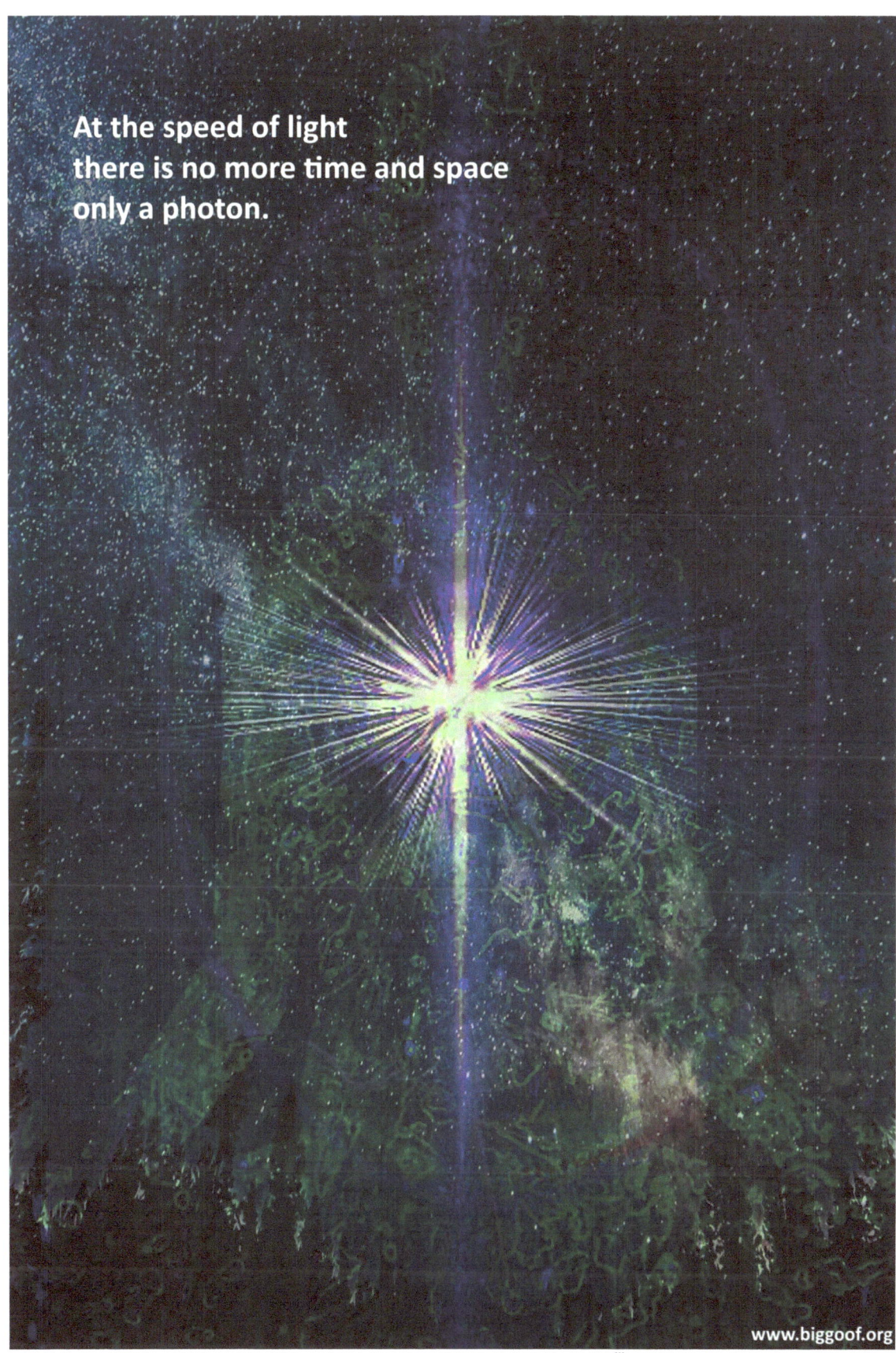

Cosmic Photonic Layer and Special Relativity[iii]. Collage.

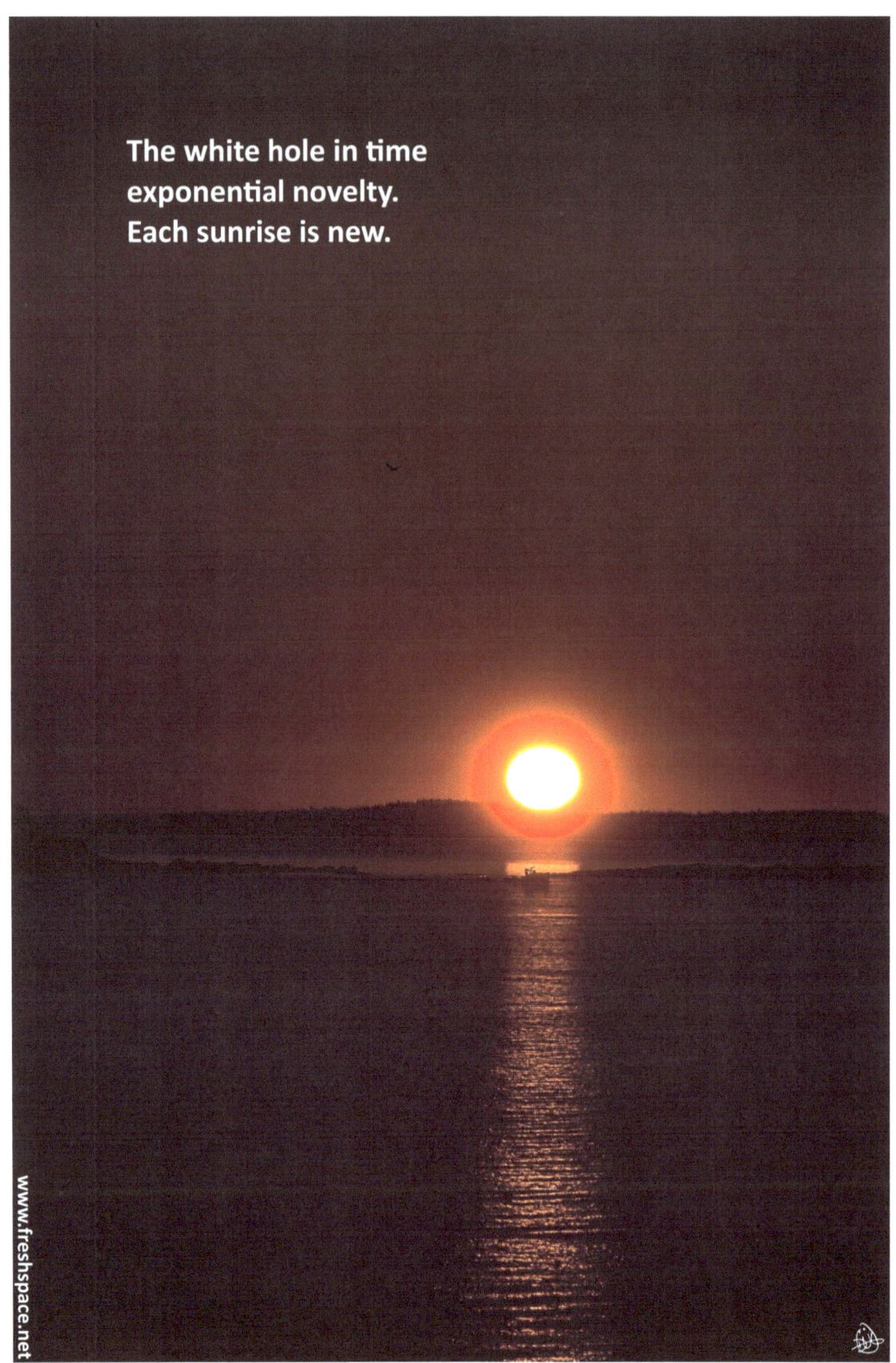

Fresh[iv] Sunrise. Rockport, Maine. August 7th, 02017.

About the Author

Düg Fresh is the author of several books including *The Children's Book of Colors: A journey from primary colors to the visual spectrum and how we see*, *A Thousand and One Appalachian Tales: A Journey along the A.T. and through the heart of Chapel Perilous* and *The Fictionary: A vocabulous flexicon of jocumolecular jingo and colloquialiscious flapinations in the key of G*. He is also founder of the International Peace Trail Project, dedicated to the creation of "a footpath for those seeking fellowship with Earth" and to the idea that if you build it, peace will come. For more information on the IPT, please visit www.peacetrail.org. He believes humor is the missing component to world peace and has developed the formula: ☮=♥☺² ~ Peace equals love times happiness squared. See www.biggoof.org for more.

Other books by Düg Fresh

The Emperor's New Parade: A re-imagining of the Hans Christian Andersen classic for the darkest timeline – December 22, 2018 ISBN-13: 978-1792112621

The Children's Book of Colors Paperback: A journey from primary colors to the visual spectrum and how we see – April 17, 2018 ISBN-13: 978-1980860655

The Visual Fictionary: A vocabulous flexicon of jocu-molecular jingo and colloquialiscious flapinations in the key of G in color, visualized - Apr 10, 2018 ISBN-13: 978-1980527848

Peaks in the Landscape: A Visual Collection of Haiku – April 9, 2018 ISBN-13: 978-1980788256

On the value and importance of an International Peace Trail: A Project in Global Planning - Mar 20, 2018 ISBN-13: 978-1980605805

A Thousand and One Appalachian Tales: A Journey along the A.T. and through the heart of Chapel Perilous - Aug 8, 2011 ISBN-13: 978-1602648517

A Thousand and One Appalachian Tales: Color Supplement – July 2, 2018 ISBN-13: 978-198332538

"Oh, that you would bless me and enlarge my territory! Let your hand
be with me, and keep me from harm so that I will be free from pain."
Prayer of Jabez, 1 Chronicles 4:10, NIV.

[i] **Changing the Narrative on Native Americans**
https://www.firstnations.org/wp-content/uploads/2018/12/%E2%80%A2MessageGuide-Allies-screen-spreads_1.pdf
Native American Resources at the American Antiquarian Society
https://www.americanantiquarian.org/native-american-resources
Tribal Communities
https://www.nal.usda.gov/ric/tribal-communities
Native American Rights Fund
https://www.narf.org/
Resources for Native Americans
https://www.albany.edu/career/audiences/native_americans.shtml
Native American Resources
http://www-bcf.usc.edu/~cmmr/Native_American.html
Partnership with Native Americans
http://www.nativepartnership.org
How You Can Help Native Americans
https://www.powwows.com/can-help-native-americans/
First Nations
https://www.firstnations.org
10 Things to know about Indigenous Peoples
https://stories.undp.org/10-things-we-all-should-know-about-indigenous-people
Indigenous Peoples of the World
https://intercontinentalcry.org/indigenous-peoples/

[ii] **Appalachian Trail Conservancy**
http://www.appalachiantrail.org/
Appalachian Long Distance Hikers Association
https://aldha.org
One Step at a Time: Hiking the Appalachian National Scenic Trail
https://www.americanforests.org/magazine/article/one-step-at-a-time-hiking-the-appalachian-national-scenic-trail/
An Appalachian Trail: A Project in Regional Planning
https://placesjournal.org/article/an-appalachian-trail-a-project-in-regional-planning
One Step at a Time: Hiking the Appalachian National Scenic Trail
https://www.americanforests.org/magazine/article/one-step-at-a-time-hiking-the-appalachian-national-scenic-trail

Top 50 Long Distance Hiking Trails In The USA | Boot Bomb
https://bootbomb.com/info/hiking-trails/top-50-long-distance-hiking-trails-usa/
10 of the best long-distance trails for hikers around the world
https://www.cnn.com/travel/article/top-treks/index.html
The International Peace Trail Project
www.peacetrail.org

[iii] **Einstein's Theory of Special Relativity**
https://www.space.com/36273-theory-special-relativity.html
Space-Time And The Speed Of Light | Einstein's Relativity

https://www.youtube.com/watch?v=xvZfx7iwq94
Riding a Beam of Light & Travelling At The Speed Of Light
http://www.chongonation.com/articles/oldarticles/light_speed.htm

[iv] **What Is A White Hole?**
https://www.iflscience.com/physics/what-white-hole/
What is the difference between black hole, white hole & wormhole?
https://www.quora.com/What-is-the-difference-between-black-hole-white-hole-wormhole
White Holes: Black Holes' Neglected Twins
https://www.space.com/white-holes.html

Singularity: Explain It to Me Like I'm 5-Years-Old
https://futurism.com/singularity-explain-it-to-me-like-im-5-years-old
The Jumping Jesus Phenomenon
http://www.rawilson.com/sitnow.html
The Jumping Jesus Phenomenon
http://wikibin.org/articles/the-jumping-jesus-phenomenon.html
Robert Anton Wilson - The Jumping Jesus Phenomenon
https://www.youtube.com/watch?v=EQTYEGDIRks

Knowledge Doubling Every 12 Months, Soon to be Every 12 Hours
http://www.industrytap.com/knowledge-doubling-every-12-months-soon-to-be-every-12-hours/3950
Accelerating Acceleration: Towards Tomorrow
https://www.bfi.org/dymaxion-forum/2011/12/accelerating-acceleration-towards-tomorrow
Knowledge Creation : Globalization and Exponential Growth
https://open-organization.com/en/2017/04/26/knowledge-creation-globalization-and-exponential-growth/
Knowledge doubling
https://epoq.fandom.com/wiki/Knowledge_doubling

Everything Old Is New Again
https://youtu.be/Z9FfI4-oRDo?t=8

www.ingramcontent.com/pod-product-compliance
Lightning Source LLC
Chambersburg PA
CBHW041318180526
45172CB00004B/1142